ideals® EASTER

Stronger than the dark, the light;
stronger than the wrong, the right;
faith and hope triumphant say,
"Christ will rise on Easter Day!"

—PHILLIPS BROOKS

NASHVILLE, TENNESSEE

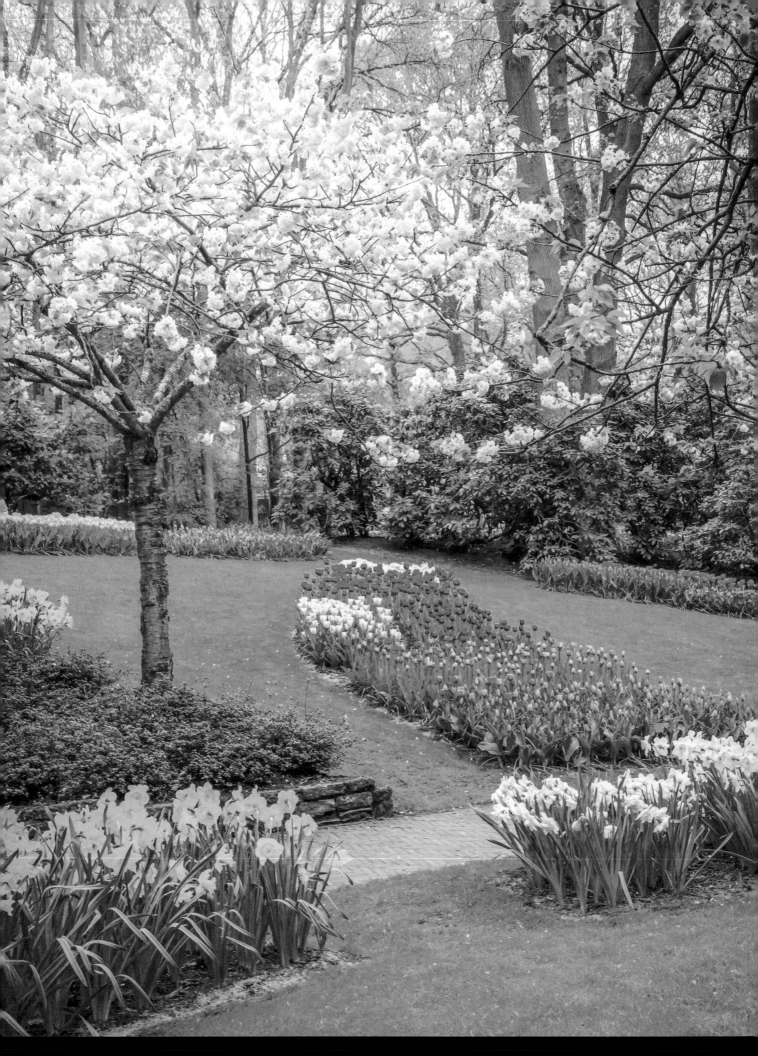

Our Lord has written the promise of resurrection, not in books alone but in every leaf of springtime.
—MARTIN LUTHER

Kindly Spring

John Newton

Kindly spring again is here,
trees and fields in bloom appear.
Hark! The birds with artless lays
warble their Creator's praise.

Where in winter all was snow,
now the flowers in clusters grow;
and the corn, in green array,
promises a harvest day.

Lord, afford a spring to me;
let me feel like what I see;
speak, and by Thy gracious voice,
make my drooping soul rejoice.

On Thy garden deign to smile,
raise the plants, enrich the soil;
soon Thy presence will restore
life to what seemed dead before.

Springtime

Linda C. Grazulis

The winter freeze has finally ended,
for God has sent us springtime once again,
as pirouetting snowflakes drifted out of sight
we praise God for the Easter blossoms He will send.

Hyacinths and yellow buttercups are sprouting
 on the scene,
while daffodils and tulips make one yearn for more.
A confetti of sweet loveliness dances so serenely,
leaping and tiptoeing through springtime's open door.

Let us welcome her anticipated arrival
As an awesome rainbow arches across the
 pale blue sky.
Showers are splashing, ducks are quacking,
Finding a four-leaf clover removes that winter sigh.

Clap your hands as she entertains us
With cherry blossoms and azaleas colorful and grand.
Oh thank You, God, for springtime,
I'm truly the season's biggest fan.

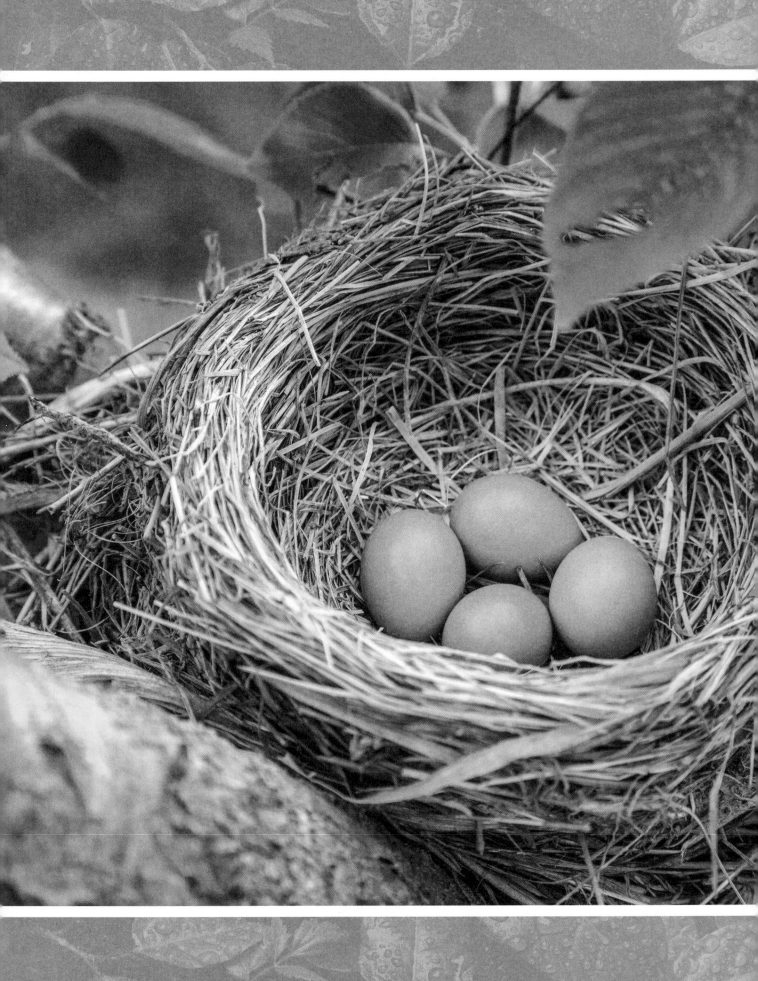

A Day Full of Bird Sounds
Eileen Spinelli

Robin wakes me with a song.
Sparrow chirps the whole day long.
Hummingbird has wings that hum.
Woodpecker likes to drum.
Pigeon coos. So does dove.
Gull swoops and squeals above.
Crow caws loud.
 Goose honks deep.
Baby wren goes cheep,
 cheep, cheep.
Then owl
hoots me
softly
off to sleep.

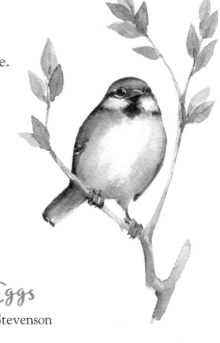

Nest Eggs
Robert Louis Stevenson

Here in the fork
the brown nest is seated;
four little blue eggs
the mother keeps heated.

Soon the frail eggs they shall
chip, and upspringing
make all the April woods
merry with singing.

Younger than we are,
O children, and frailer,
soon in the blue air they'll be,
singer and sailor.

We, so much older,
taller, and stronger,
we shall look down on the
birdies no longer.

They shall go flying
with musical speeches,
high overhead in the
tops of the beeches.

In spite of our wisdom
and sensible talking,
we on our feet must go
plodding and walking.

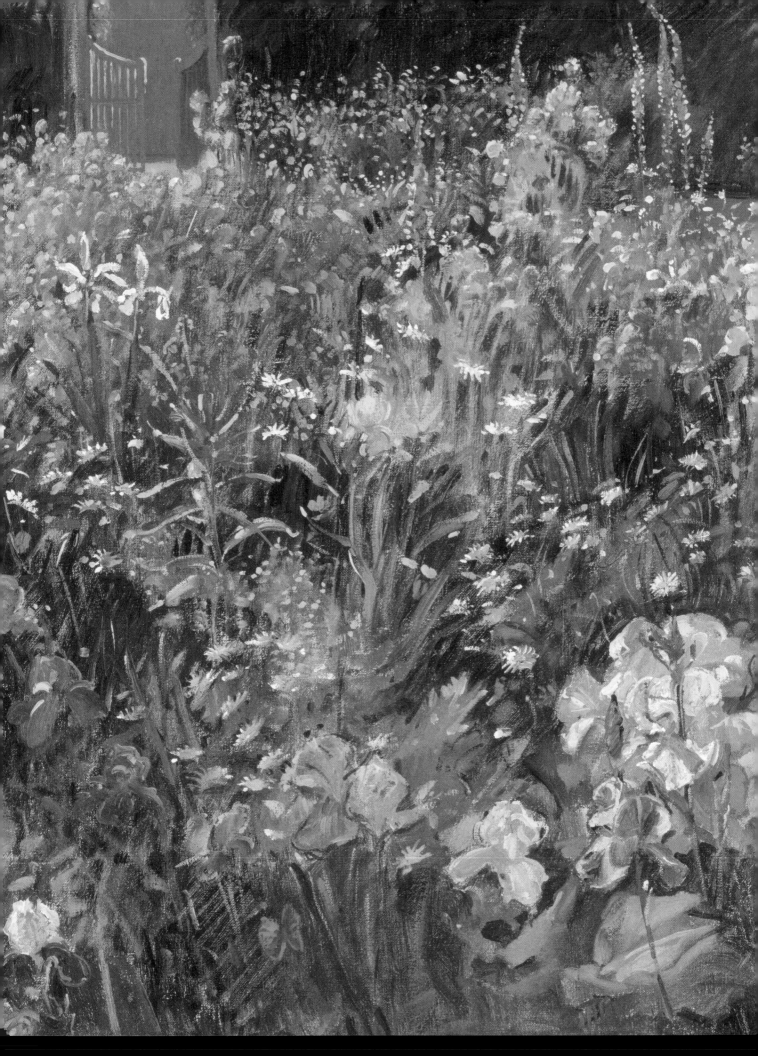

All Things Bright and Beautiful
Cecil Frances Alexander

All things bright and beautiful,
all creatures great and small,
all things wise and wonderful,
the Lord God made them all.

Each little flower that opens,
each little bird that sings,
He made their glowing colors,
He made their tiny wings.

The purple-headed mountain,
the river running by,
the sunset, and the morning,
that brighten up the sky;

The cold wind in the winter,
the pleasant summer sun,
the ripe fruits in the garden,
He made them every one.

The tall trees in the greenwood,
the meadows where we play,
the rushes by the water,
we gather every day.

He gave us eyes to see them,
and lips that we might tell,
how great is God Almighty,
who has made all things well.

The Flower
Alfred, Lord Tennyson

Once in a golden hour
I cast to earth a seed.
Up there came a flower,
the people said, a weed.

To and fro they went
through my garden bower,
and muttering discontent
cursed me and my flower.

Then it grew so tall
it wore a crown of light,
but thieves from o'er the wall
stole the seed by night.

Sow'd it far and wide
by every town and tower,
till all the people cried,
"Splendid is the flower!"

Read my little fable:
he that runs may read.
Most can raise the flowers now
for all have got the seed.

And some are pretty enough,
and some are poor indeed;
and now again the people
call it but a weed.

SWEET ROCKET, FOXGLOVES AND IRISES *by Timothy Easton.*
Image © Timothy Easton/Bridgeman Images

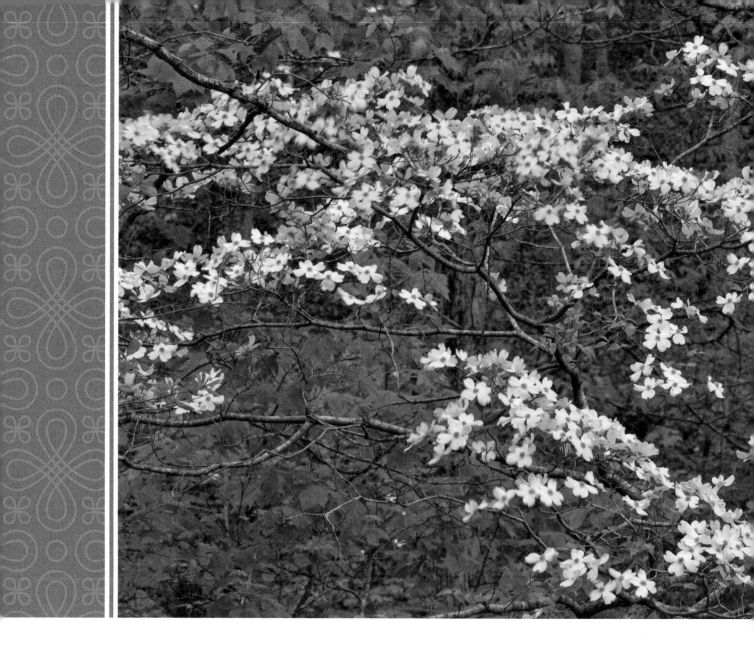

Easter Week

Charles Kingsley

See the land, her Easter keeping,
rises as her Maker rose.
Seeds, so long in darkness sleeping,
burst at last from winter snows.

Earth with heaven above rejoices;
fields and gardens hail the spring;
sloughs and woodlands ring with voices
while the wild birds build and sing.

You, to whom your Maker granted
powers to those sweet birds unknown,
use the craft by God implanted;
use the reason not your own.

Here, while heaven and earth rejoices,
each his Easter tribute bring,
work of fingers, chant of voices,
like the birds who build and sing.

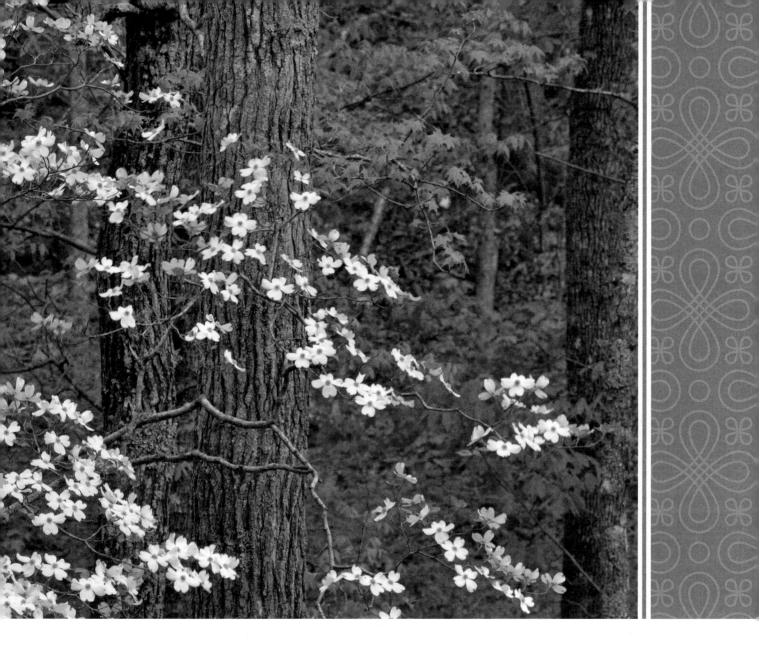

The Dogwood Tree

Author Unknown

In Jesus' time the dogwood grew
to a stately size and a lovely hue.
'Twas strong and firm as oak branches
 interwoven;
for the cross of Christ its timber was chosen.

Seeing the distress at the use of its wood,
Christ made a promise that still holds good:
"Never again shall the dogwood grow
large enough to be used so.

It shall be slender and twisted be
with blossoms like the cross for all to see.
As bloodstains the petals marked in brown;
the blossom's center shall wear a
 thorny crown.

All who see it will remember Me,
crucified on a cross from the dogwood tree,
cherished and protected this tree shall be,
a reminder to all of my agony."

Springtime in the Country

Gladys Taber

The snowdrops are out around the twenty-second. The lovely pearl-white bells seem too delicate to bear the brunt of that March wind, but they do. The first clump that opens is a cause for special celebration. The scilla is fragile, too, and so is the first pale amethyst crocus. Bloodroot and dogtooth violets— all the flowers of spring seem too frail to last out the end of the cold. And they are all the more exquisite because they seem so alone in the world.

When the peepers begin to cry in the night, I like to lie awake just to listen to the sweet, thin crying. No music can compare with it, for it is the voice of new life beginning, or a new season coming; it is the final period to the silent sentences of winter.

The swamp still looks dark and wintry in the cold light of the moon, but in the swamp all the little folk are stirring, and the brave song makes the heart glad.

Surely, I think, there is no grief so deep that might not be eased by the sound of singing in spring, no joy so perfect that might not seem even better.

Without the long winter, would we love the spring so much? I will leave that to the philosophers to answer. For myself, I can just go up to the old orchard on the top of the hill, with Honey puffing beside me, and let the great sweep of the wind blow away everything tired and old and sad and bring the sweet thunder in the blood of spring!

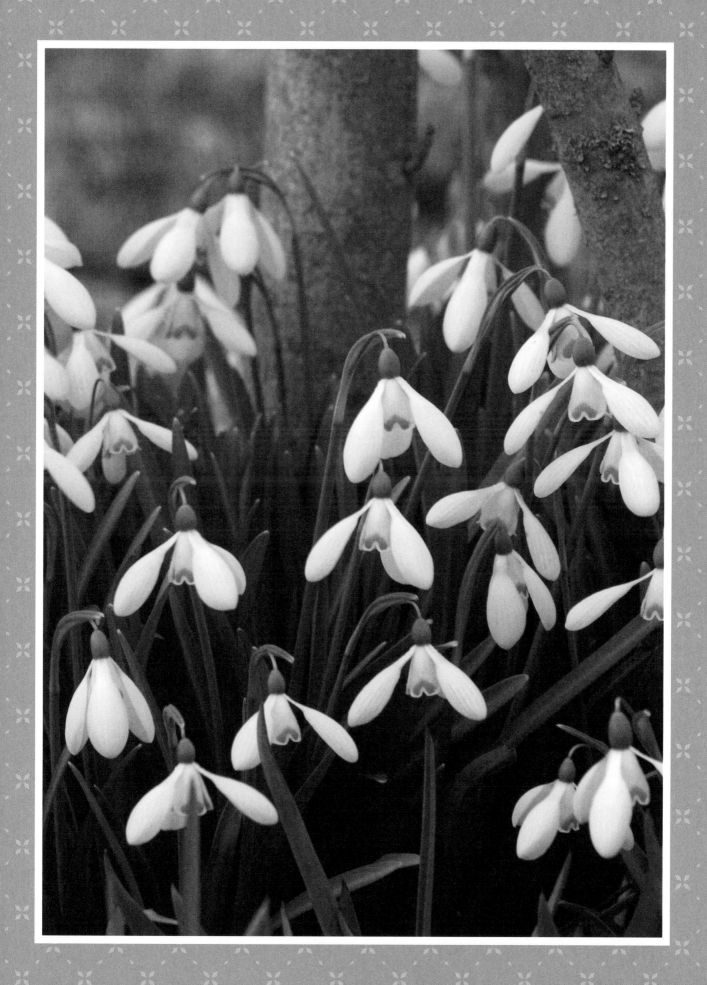

The Day We Flew the Kites

Frances Fowler

String!" shouted Brother, bursting into the kitchen. "We need lots more string."

It was Saturday. As always, it was a busy one, for "Six days shalt you labor and do all thy work" was taken seriously then. Outside, Father and Mr. Patrick next door were doing chores.

Inside the two houses, Mother and Mrs. Patrick were engaged in spring cleaning. Already, woolens flapped on backyard clotheslines.

Somehow the boys had slipped away to the back lot with their kites. Now, even at the risk of having Brother impounded to beat carpets, they had sent him for more string. Apparently there was no limit to the heights to which kites would soar today.

My mother looked out the window. The sky was piercingly blue, the breeze fresh and exciting. Up in all that blueness sailed great puffy billows of clouds. It had been a long, hard winter, but today was spring.

Mother looked at the sitting room, its furniture disordered for a Spartan sweeping. Again her eyes wavered toward the window. "Come on, girls! Let's take string to the boys and watch them fly the kites a minute." On the way we met Mrs. Patrick, laughing gingerly, escorted by her girls.

There never was such a day for flying kites! God doesn't make two such days in a century. We played all our fresh twine into the boys' kites, and still they soared. We could hardly distinguish the tiny, orange-colored specks. Now and then we slowly reeled one in, finally bringing it dipping and tugging to earth, for the sheer joy of sending it up again. What a thrill to run with them, to the right, to the left, and see our poor, earthbound movements reflected minutes later in the majestic sky-dance of the kites! We wrote wishes on slips of paper and slipped them over the string. Slowly, irresistibly, they climbed up until they reached the kites. Surely all such wishes would be granted!

Even our fathers dropped hoe and hammer and joined us. Our mothers took their turns, laughing like schoolgirls. Their hair blew out of their pompadours and curled loose about their cheeks; their gingham aprons whipped about their legs. Mingled with our fun was something akin to awe. The grownups were really playing with us! Once I looked at Mother and thought she looked actually pretty. And her over forty!

We never knew where the hours went on that hilltop day. There were no hours, just a golden, breezy *Now*. I think we were all a little beyond ourselves. Parents forgot their duty and their dignity; children forgot their combativeness and small spites. "Perhaps it's like this in the Kingdom of Heaven," I thought confusedly.

It was growing dark before, drunk with sun and air, we all stumbled sleepily back to the houses. I suppose we had some sort of supper. I suppose there must have been a surface tidying up, for the house on Sunday looked decorous enough.

The strange thing was, we didn't mention that day afterward. I felt a little embarrassed. Surely none of the others had thrilled to it as deeply as I. I locked the memory up in that deepest part of me where we keep "the things that cannot be and yet are."

The years went on, then one day I was scurrying about my own kitchen in a city apartment, trying to get some work out of the way while my three-year-old insistently cried her desire to "go park and see ducks."

"I *can't* go!" I said. "I have this and this to do, and when I'm through I'll be too tired to walk that far."

My mother, who was visiting us, looked up from the peas she was shelling. "It's a wonderful day," she offered, "really warm, yet there's a fine, fresh breeze. It reminds me of that day we flew the kites."

I stopped in my dash between stove and sink. The locked door flew open, and with it a gush of memories. I pulled off my apron. "Come on," I told my little girl. "You're right, it's too good a day to miss."

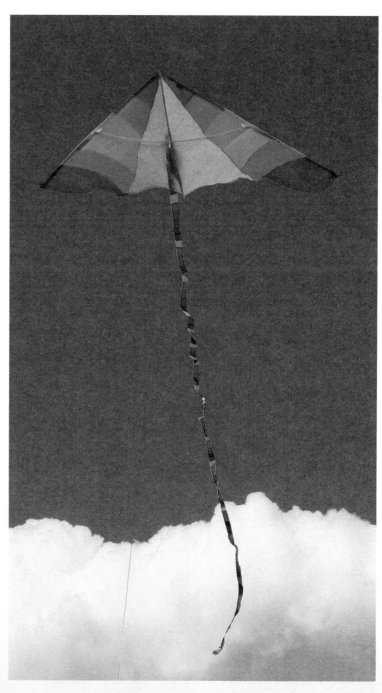

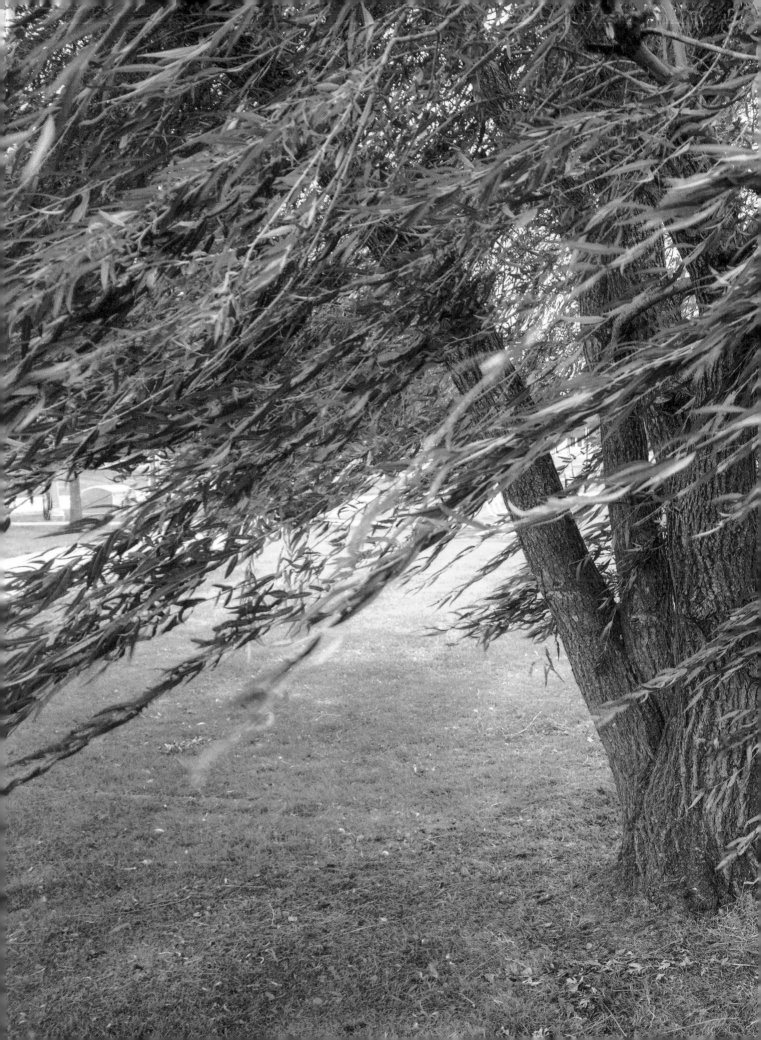

Who Has Seen the Wind?

Christina Rossetti

Who has seen the wind?
Neither I nor you:
but when the leaves hang
 trembling,
the wind is passing through.

Who has seen the wind?
neither you nor I:
but when the trees bow down
 their heads,
the wind is passing by.

There Was a Roaring in the Wind All Night

William Wordsworth

There was a roaring in the wind all night;
the rain came heavily and fell in floods;
but now the sun is rising calm and bright;
the birds are singing in the distant woods;
over his own sweet voice the stock-dove broods;
the jay makes answer as the magpie chatters;
and all the air is filled with pleasant noise
 of waters.

All things that love the sun are out of doors;
the sky rejoices in the morning's birth;
the grass is bright with raindrops; on the moors
the hare is running races in her mirth;
and with her feet, she from the plashy earth
raises a mist, that, glittering in the sun,
funs with her all the way, wherever she
 doth run.

Rain Music
Joseph S. Cotter Jr.

On the dusty earth-drum
beats the falling rain;
now a whispered murmur,
now a louder strain.

Slender, silvery drumsticks,
on an ancient drum,
beat the mellow music
bidding life to come.

Chords of earth awakened,
notes of greening spring,
rise and fall triumphant
over everything.

Slender, silvery drumsticks
beat the long tattoo—
God, the Great Musician,
calling life anew.

April Rain
Robert Loveman

It is not raining rain for me,
it's raining daffodils;
in every dimpled drop, I see
wild flowers on the hills.

The clouds of gray engulf the day
and overwhelm the town;
it is not raining rain to me,
it's raining roses down.

It is not raining rain to me,
but fields of clover bloom,
where any buccaneering bee
can find a bed and room.

A health unto the happy,
a fig for him who frets!
It is not raining rain to me,
it's raining violets.

Rain, Rain, April Rain
Annette Wynne

Rain, rain, April rain,
washing tree and windowpane,
tapping every spot of ground,
lest some sleepy seed be found;
I can watch you and be gay
though I cannot go to play.

Rain, rain, April rain,
washer of the hill and plain,
summer could not be so gay
if it did not rain today,
and it's fun to stay inside
and see you falling far and wide.

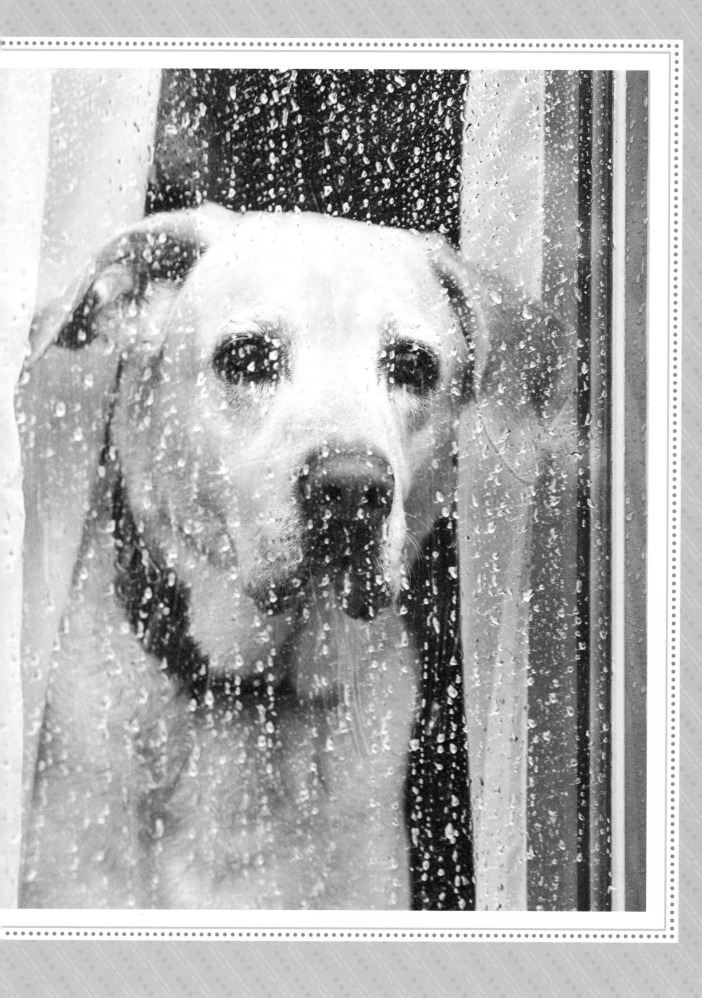

*I wandered
lonely as a cloud that
floats on high o'er
vales and hills . . .*

—WILLIAM WORDSWORTH

Flaneuring in Spring

Eileen Spinelli

It wasn't long ago that I learned the term "flaneuring." One definition is: to wander without intention. That is, to go into the world with no agenda.

Walking for exercise? Well, that's exercise. Walking to the grocery store for a dozen eggs? That's an errand. Strolling on a spring day, stopping at a patch of onion grass, leaning into it, pinching a wisp, breathing in the pungent scent of it? That's flaneuring. Can you blame me for being charmed?

There's fine flaneuring to be had in any season. My favorite flaneuring season happens to be spring. Old walking shoes, my blue jacket, an apricot in my pocket, and I'm all set. I go out the back door. Here is the path by the lake. Which way to go?

I toss a penny. Heads. I go right.

Right brings me to a clump of daffodils in the thin woods. I think of Wordsworth's poem. And there, heading into the water, a pair of geese and three toddling goslings. I see a rock. I collect heart-shaped rocks. This one isn't shaped like a heart, but it's smooth. Some of the grandchildren paint rocks. I pick it up. Ahhh . . . a bench.

Fashioned from a fallen log. I sit and watch the water. I eat my apricot.

And now . . . home or over the rickety bridge?

Over the rickety bridge I go. Sky turns dark. Change of plans. Head back. Oops! A downpour. I pass a neighbor. Both of us running through the rain. Laughing. Spring rain is not unpleasant.

Flaneuring can happen in the city as well. Toss a penny. Left, or right?

Right. Candy shop. Remember how you used to love lemony jellybeans? Bet they sell them here. Bus stop. Sit on the bench, enjoy your jellybeans, and do some people-watching. Smile at passersby and see how many smile back. Most will, especially in spring.

Home yet? Or over to the vendor selling straw hats? To the vendor. A pink hat catches your eye. How long has it been since you've worn a hat? Go ahead. Buy it. The vendor says you are his first sale. He tells you he has a son going off to college in the fall. You wish his son well. You don your new hat and head home.

Home . . . returning to . . . a cozy final stop in any day of flaneuring.

The Wild Violet
Hannah Flagg Gould

Violet, violet, sparkling with dew,
down in the meadowland wild where you grew,
how did you come by the beautiful blue
with which your soft petals unfold?
And how do you hold up your tender,
 young head
when rude, sweeping winds rush along o'er
 your bed,
and dark, gloomy clouds ranging over you shed
their waters so heavy and cold?

No one has nursed you, or watched you an hour,
or found you a place in the garden or bower;
and they cannot yield me so lovely a flower,
as here I have found at my feet!
Speak, my sweet violet! Answer and tell
how you have grown up and flourished so well,
and look so contented where lowly you dwell,
and we, thus by accident, meet!

"The same careful hand," the Violet said,
"that holds up the firmament, holds up my head!
And He, who with azure the skies overspread,
has painted the violet blue.
He sprinkles the stars out above me by night
and sends down the sunbeams at morning with light
to make my new coronet sparkling and bright,
when formed of a drop of his dew!

"I've naught to fear from the black, heavy cloud
or the breath of the tempest that comes strong
 and loud!
Where, born in the lowland and far from the crowd,
I know and I live but for One.
He soon forms a mantle about me to cast,
of long, silken grass, till the rain and the blast
and all that seemed threatening have
 harmlessly passed,
as the clouds scud before the warm sun!"

Violets
Alice Dunbar Nelson

I had no thought of violets of late,
the wild, shy kind that spring beneath your feet
in wistful April days, when lovers meet
and wander through the fields in raptures sweet.
The thought of violets meant florists' shops,
and bows and pins, and perfumed papers fine;
and garish lights and mincing little fops
and cabarets and songs and deadening wine.

So far from sweet real things my thoughts
 had strayed,
I had forgot wide fields and clear brown streams;
the perfect loveliness that God has made,
wild violets shy and Heaven-mounting dreams.
And now—unwittingly, you've made me dream
of violets and my soul's forgotten gleam.

Easter Sidewalk Chalk

Clara Brummert

When I think of Easter, my childhood memories take shape in soft, pastel colors. Marshmallow chicks dusted with pale, yellow sugar. Pink satin hair ribbons worn with a dotted swiss dress. Pastel sidewalk chalk nestled in a hidden wicker basket. Easter lilies at the foot of a church cross rise up in my memory, too, bringing with them the Resurrection story, an account of how Jesus' broken body opened the hues of heaven to mankind by way of forgiveness.

One day, when I was just a young girl, a simple piece of chalk afforded me an Easter lesson; and it was then that I learned how brokenness can give way to the most beautiful of colors.

That morning, after racing through the house to find our baskets, my little brother and I huddled to check out our loot. I giggled when I found bike streamers and a box of chalk peeking from behind a chocolate bunny. I looked his way and saw sunglasses perched on his nose. He happily clutched a plastic harmonica in one hand and a bottle of bubbles in the other.

After lunch, we grabbed our baskets and headed to the park. I slung mine over a handlebar and pedaled the short distance, leading our little parade. He marched behind, puffing out a tune on the harmonica.

Birdsong greeted me as I hopped from my bike. I studied the expanse of concrete, like an artist imagining how a masterpiece might take form on a canvas. Then I settled in near the monkey bars and opened my chalk.

I tucked the pink piece back into my basket. Its whimsical color, soft as cotton candy, was my favorite, and I was saving it to draw a rose garden near the slide.

Humming, I made the first strokes of yellow, and a daisy began to blossom on the sidewalk. Soon my brother plopped down beside me. Anxious to help, he wiggled as my bouquet grew.

With great flourish, I outlined several leaves and passed him the green chalk. He sprawled out and gave full attention to coloring within the lines. I stretched out beside him and added dainty tendrils to the stems.

Finally finished with the daisies, we stopped to root through our baskets. I protectively covered the pink chalk with Easter grass as I munched on malt balls. With sticky fingers and a chocolate grin, my brother produced the bubble wand, and we giggled as we bobbed through a sea of floating bubbles.

Eventually, flushed and thirsty, I skipped home for lemonade, and I waited patiently while Momma squeezed the lemons. With a paper cup in each hand, I gingerly made my way back to the park, careful not to spill our drinks. In the distance, I saw my brother's arm moving over the sidewalk in broad strokes. He'd taken the pink chalk from my basket!

I gasped and began to run, heedless of the

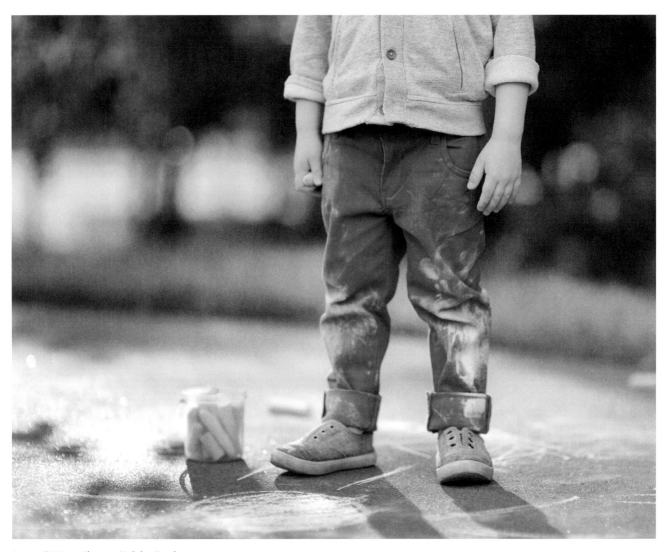

Image © Maria Sbytova/Adobe Stock

lemonade sloshing from the cups. "It's a stop sign!" he announced with a proud grin as I ran up. He pointed to a pink sign with a crooked post that he'd drawn near my smudged bouquet.

I frowned at the pink nub in his hand, then gaped at a long, dotted line at his feet. His shoulders drooped as he looked down too.

"It's a road for your bike," he weakly explained.

Although broken pink shards were scattered on the sidewalk, the rose-colored road drew me in. I hopped on my bike and steered into a lane, rolling my eyes to keep from grinning.

He beamed and held up a hand like a traffic cop. I slowed, but he gave a toot on the harmonica and waved me through. I passed by the spray of chalk daisies, tickled that they looked like wildflowers blooming near a stop sign. I pedaled around again, this time stopping for his hand.

"That'll be fifty dollars," he said, holding out his palm for payment. I giggled and gave him a high-five for the toll. Then I circled the bright pink road again, with my bike streamers flying.

Easter Baskets
Marianne Coyne

Chocolate bunnies fill the room
with a scent that makes me swoon
and think of days so long ago
with Easter baskets hidden low.

One for me, sister, and brother,
we searched for them, one with the other,
behind the couch, beside a chair,
until all three were found quite fair.

The bounty of each basket held
our senses captive, quite compelled.
Pastel-colored eggs galore,
marshmallow chicks, and so much more.

"Just one bite!" we'd plead with Mother,
me, my sister, and our brother.
Until she couldn't help but say,
"All right, my dears, but then away!"

Beautiful Baskets
Pamela Love

The center of attention
of a basket, Easter day,
are the treasures filling it:
sweets, toys, or a bouquet.

It's not hard to overlook
a basket when it holds
delicious treats,
 bright flowers,
or eggs, blue, pink,
 and gold.

But someone took the care
 to weave
the reeds into a form
that safely guards
 delightful gifts
on this Sunday morn.

Just like our loving Lord above
who made our world that we
can celebrate this Easter in
so very joyfully.

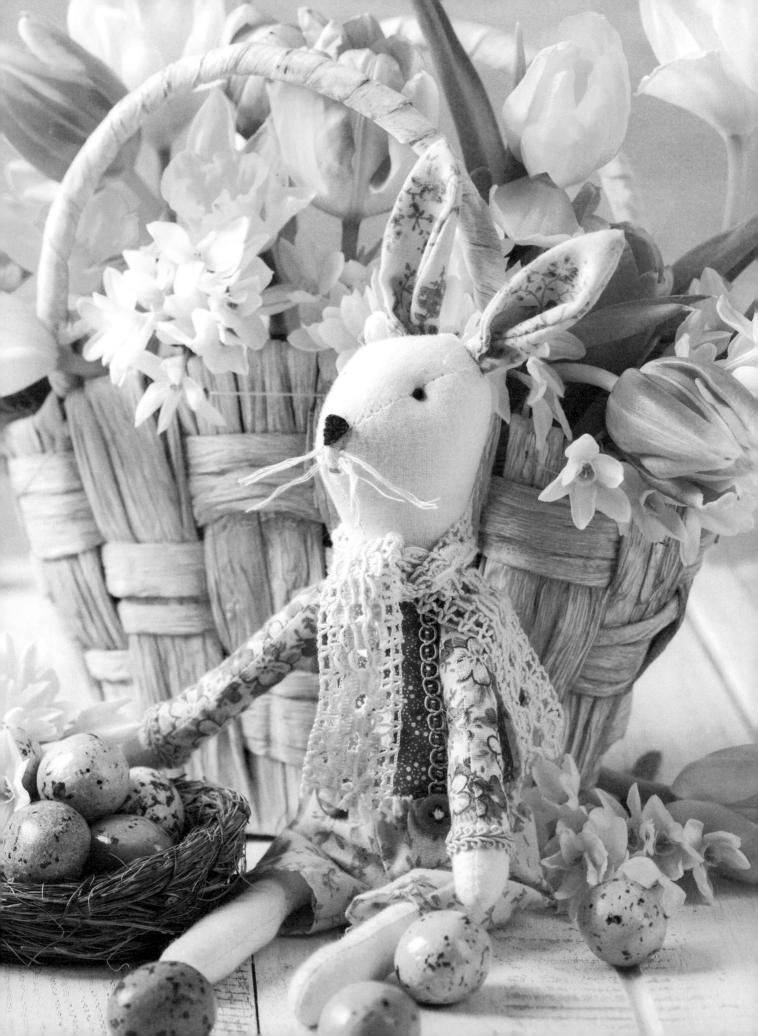

Hunting for Easter

Anne Kennedy Brady

Scrolling through my social media feed around Easter last year, I came across an article heralding "The Easter egg hunt you absolutely must do!" The author detailed complicated rules involving hidden coins, color coding, and, in my opinion, far too much math. She promised that this would become a beloved family tradition, but I suspected my kids would not develop fond memories if Mom had to tackle algebra every Easter morning. I closed the computer and went back to stuffing jellybeans in plastic eggs.

When I was very young, Easter egg hunts were humble. We woke up early and raced to the kitchen to find our baskets. Weather permitting, we'd collect eggs from around our yard, my parents steering my older brothers away from the easier finds. As I grew older, we'd sometimes join egg hunts sponsored by local parks or our church. One memorable year, the new children's minister decided to hide eggs the night before to make the morning setup less hectic. What she didn't count on was a flock of enterprising seagulls, happy to take advantage of a pre-dawn buffet! On Easter morning, all the kids showed up to a hillside covered in ransacked plastic eggshells and empty candy wrappers.

When my own son was old enough to gather eggs, we met up with friends at a local church and set the toddlers free. At the "go" signal, both boys eagerly picked up the first egg they found and plopped right down to open it. But last Easter my son, at four and a half, had mastered treasure hunts. Trouble was that his sister was now the toddler. He'd been learning letters, so I marked his eggs with an M for Milo and hers with an H for Helen. When he realized her eggs were filled with yogurt melts, he was happy to relinquish the "H" eggs, and even helped her find a few! "Let's hide them all again!" was the request for days after.

I've outgrown candy eggs (mostly), but I still love a good treasure hunt. So this year, I decided to search out the perfect recipe for Easter breakfast. Since my husband and I are trying to eat healthier, my sugary concoctions have taken a back seat; but Easter morning would be different. Easter is the breaking of a fast after all. I would bake again! I settled on coffee cake. My husband was thrilled, though my son was disappointed. What good is a cake with no frosting?

Very good, it turns out. I pored through an old cookbook and found a recipe that looked like it would deliver just what I was after. I rose early-ish to get started and relished the time alone in the kitchen. Just me and my recipe. Spring in Chicago is still chilly, so the warm scent of cinnamon slowly filling the house made everyone feel cozy as they emerged from bed and padded to the kitchen, still in jam-

mies. After taking the cake out of the oven, I whipped up a glaze and sold it to my son as frosting as he helped me drizzle it on top. After the egg hunt (priorities, you know) we settled into our kitchen chairs and reveled in the delicious togetherness of Easter morning.

Finding a recipe may not seem as thrilling as a childhood egg hunt, but in searching for that perfect coffee cake recipe, I hoped to find something more. I longed to revisit the Easters of my youth—warm in the embrace of my family, safe in the traditions we repeated each year. We, however, are not that same family. We live in a city, not the suburbs. Our kids are young and changing fast, and our extended family lives far away. I often ponder what our traditions will be. What will my kids take with them into adulthood as they remember the story of Easter—this surprise and wonder of new life emerging from darkness? Maybe it'll be an egg hunt on our urban back deck. Maybe it will be a perfectly executed breakfast pastry. Or maybe all they need is that intangible sense of peace that comes from a home filled with love, laughter, and hope. And a dash of cinnamon.

Sour Cream Coffee Cake

TOPPING

1	cup chopped walnuts, almonds, or pecans
½	cup brown sugar
2	teaspoons ground cinnamon

COFFEE CAKE

3	cups all-purpose flour
1	tablespoon baking powder
1	teaspoon baking soda
1	teaspoon salt
¾	cup butter, softened
1	cup granulated sugar
½	cup brown sugar
2	teaspoons vanilla extract
3	large eggs
1½	cups sour cream

Preheat oven to 350°F. Spray a 9-inch springform pan with nonstick spray. In a small bowl, combine nuts, ½ cup brown sugar, and cinnamon; set aside. In a medium bowl, sift flour, baking powder, soda, and salt; set aside. In a large bowl, cream butter with granulated sugar, ½ cup brown sugar, and vanilla extract; add eggs, 1 at a time, beating until mixture is light and fluffy. Add dry ingredients alternately with sour cream; mix well. Pour half of batter into pan. Sprinkle ⅓ nut mixture over top, swirling with fork. Pour remaining batter over top. Sprinkle half of remaining nut mixture over top, swirling as before. Bake 60 to 70 minutes or until a toothpick inserted in center comes out clean. Cool on a wire rack 10 minutes; sprinkle remaining nut mixture over top. Serve warm. Makes 10 to 12 servings.

Loveliest of Trees
A. E. Houseman

Loveliest of trees, the cherry now
is hung with bloom along the bough
and stands about the woodland ride,
searing white for Eastertide.

Now, of my three score years and ten,
twenty will not come again
and take from seventy springs a score;
it only leaves me fifty more,

and since to look at things in bloom
fifty springs are little room,
about the woodlands I will go
to see the cherry hung with snow.

Apple Trees
Jessie Belle Rittenhouse

My childhood held a fairy sight—
a thousand apple trees,
all pink and white for my delight
and humming with the bees.

They grew upon a green hillside,
they sweetened all the air,
they spread a tent of
 blossoms wide
for my pavilion there.

I broke the branches at my will,
there was so vast a store;
from out my arms the
 sprays would spill,
but there were always more.

Now I go out from city ways
to see the apple tree,
for if I miss her flowering days,
the year goes ill with me.

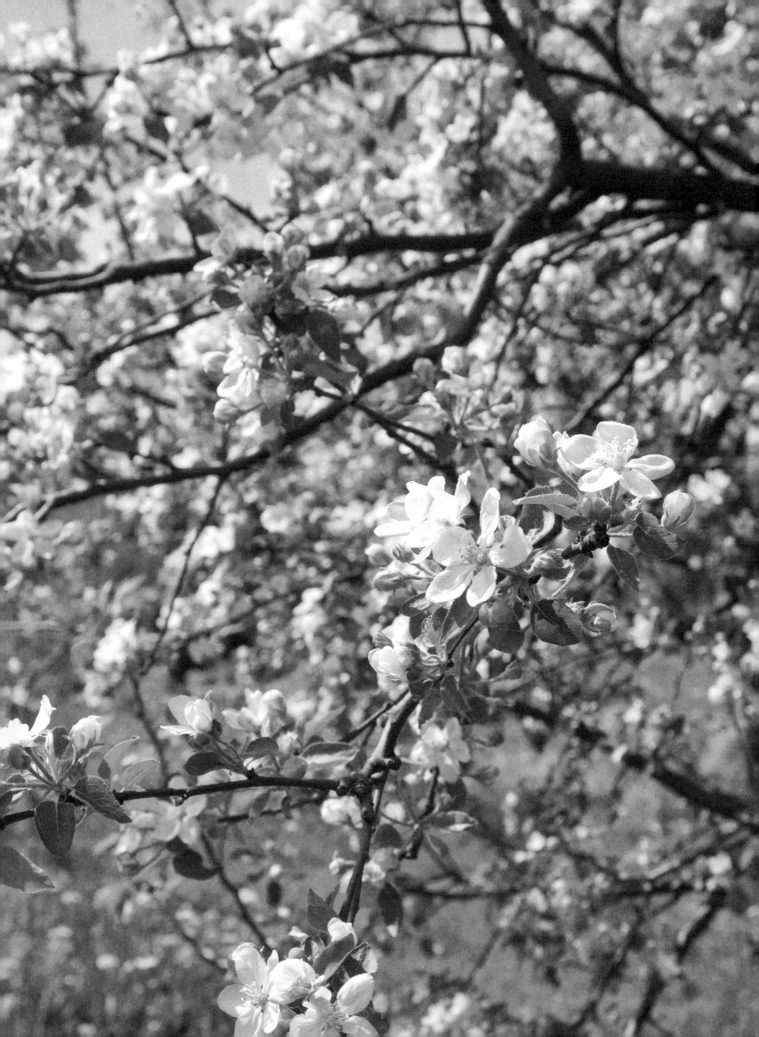

Through My Window

New Things

Pamela Kennedy

They're baa-ack!" Popping his head into the kitchen, my husband announced the annual return of the barn swallows to their nesting site in our neighbor's tile roof. I dashed upstairs and carefully peeked through the window blinds at the end of the room. This gave me a clear view of the roofline just about ten feet away. Sure enough, a pair of swallows busily plucked old feathers and pieces of straw from last year's nest, dropping them onto the ground. For the next several days I knew they would re-line their mud nest with fresh feathers, string, and bits of grass, making someplace new to lay their eggs and raise their young. Some people gauge the arrival of spring with budding daffodils, sprouting rhubarb, and light green tips on winter-browned branches. For me, it's the swallows, cleaning out the old and making something new.

These little feathered fellows remind me that it's time to dive into those things I've let languish all winter—dig around in old boxes and bags of stuff I planned to "do something with later." It's time to learn and grow and have the courage to try a new thing.

I have discovered that as I get older it becomes easier to just stick with what I know and do things the way I've always done them. But having adult children with children of their own has challenged me to take some tentative steps outside of my comfort zones, and spring is a gentle reminder to keep on with this trend. Sometimes my venturing isn't very daring, but even small changes can yield delightful results. Last year, in a frenzy of spring cleaning, I uncovered a bag filled with socks I had accumulated for a project I never got around to doing. Purchasing a book about how to make sock dolls, I set about creating sock monkeys, sock snowmen, and sock baby dolls as gifts for friends and grandchildren. After redeeming some random fabric tucked away for a rainy day, I made aprons and doll clothes. Old felt scraps became tiny rabbits tucked into carrot "sleeping bags" and miniature owls with button eyes and embroidered feathers. Making something new from something old became an exhilarating exercise in creativity!

In the kitchen I've also branched out from my usual repertoire of recipes—"golden oldies" as my family says. My daughter shared a new way to cook a pork tenderloin—it's so much easier and tastier than my old version! My son introduced me to a delicious and quick-baked salmon recipe that erased my fears of producing a dry, tasteless fillet of fish. Recently my eight-year-old grandson demonstrated a new way to add and divide

numbers—and I realized an old dog can, indeed, learn some new tricks! Then on a hike in the woods, my five-year-old granddaughter patiently explained how to tell the difference between the calls of a robin and a chickadee—oh, and how to spot a fairy as well!

My daughter sent me a special gift this spring that requires me to write an answer, in a few paragraphs, to a new question each week. In a year, there will be fifty-two stories from my recollections, bound into a book I can share with the family. Who knows what other adventures await? I've started to read some new kinds of books this year—ones that challenge my old perceptions and raise some fresh and interesting questions about "the way things are."

Just like the swallows, I'm not abandoning my nest, but I am determined to clean out some of the old stuff and maybe even toss an old idea or habit. Spring seems like a great time to do that. And, as if I needed a bit of encouragement, when I opened my well-worn Bible this morning to Isaiah 43:19 I read these words: "Behold, I am doing a new thing; now it springs forth, do you not perceive it?" It seems even the ancient prophets recognized the importance of new things!

Bits & Pieces

"I am the resurrection,
and the life."
—John 11:25

No occupation is so delightful to me as
the culture of the earth, and no culture
comparable to that of the garden.
—Thomas Jefferson

For, lo, the winter is past,
the rain is over and gone;
The flowers appear on the earth;
the time of the singing of birds is come,
and the voice of the turtle
is heard in our land.
—Song of Solomon 2:11–12

The deep roots never
doubt that spring will come.
—Marty Rubin

I must have
flowers, always
and always.
—Claude Monet

If people did not love
one another, I really don't
see what use there would
be in having any spring.
—Victor Hugo

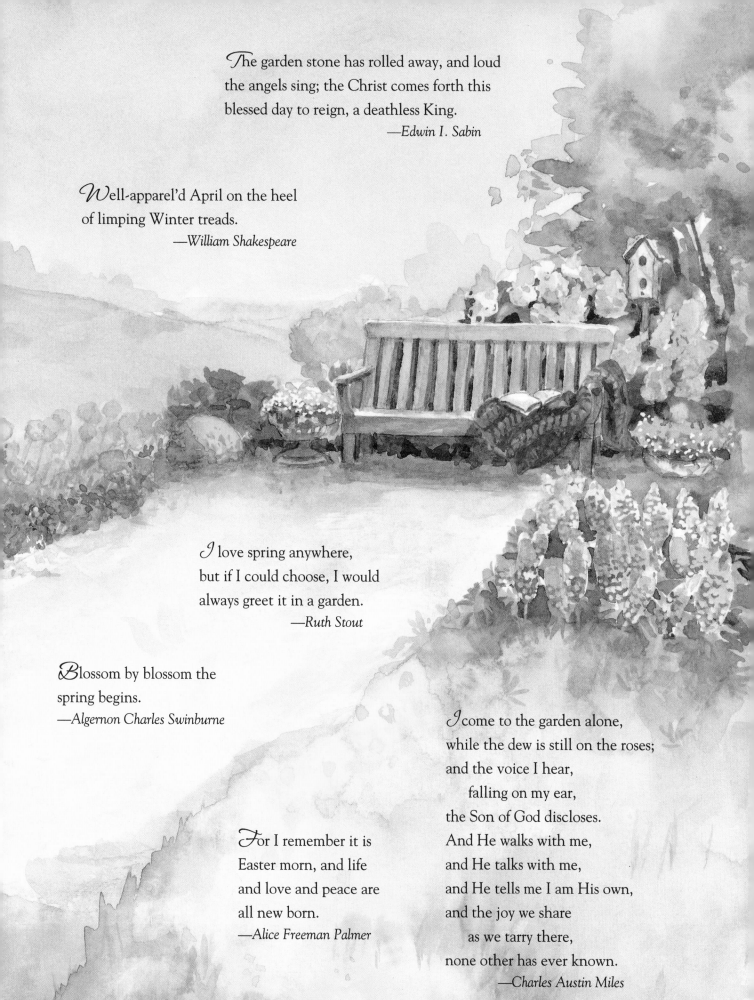

The garden stone has rolled away, and loud
the angels sing; the Christ comes forth this
blessed day to reign, a deathless King.
— *Edwin I. Sabin*

*W*ell-apparel'd April on the heel
of limping Winter treads.
— *William Shakespeare*

I love spring anywhere,
but if I could choose, I would
always greet it in a garden.
— *Ruth Stout*

*B*lossom by blossom the
spring begins.
— *Algernon Charles Swinburne*

I come to the garden alone,
while the dew is still on the roses;
and the voice I hear,
 falling on my ear,
the Son of God discloses.
And He walks with me,
and He talks with me,
and He tells me I am His own,
and the joy we share
 as we tarry there,
none other has ever known.
— *Charles Austin Miles*

*F*or I remember it is
Easter morn, and life
and love and peace are
all new born.
— *Alice Freeman Palmer*

Thus We Come to Easter

Hal Borland

Ever since man first was aware of spring, he has stood at this season with awe in his eyes and wonder in his heart, sensing the magnificence of life returning and life renewed; and something deep within him has responded, whatever his religion or spiritual belief. It is as inevitable as sunrise that man should see the substance of faith and hope in the tangible world so obviously responding to forces beyond himself or his accumulated knowledge.

For all his learning and sophistication, man still instinctively reaches toward that force beyond, and thus approaches humility. Only arrogance can deny its existence, and the denial falters in the face of evidence on every hand. In every tuft of grass, in every bird, in every opening bud, there it is. We can reach so far with our explanations, and there still remains a force beyond which touches not only the leaf, the seed, the opening petal, but man himself.

Spring is a result, not a cause. The cause lies beyond, still beyond. And it is the instinctive knowledge of this which inspires our festivals of faith and life and belief renewed. Resurrection is there for us to witness and participate in; but the resurrection around us still remains the symbol, not the ultimate truth. And men of good will instinctively reach for truth—beyond the substance of spring, of a greening, and revivifying earth, of nesting and mating and birth, of life renewed. Thus we come to Easter, and all the other festivals of faith, celebrating life and hope and the ultimate substance of belief—reaching, like the leaf itself, for something beyond, ever beyond.

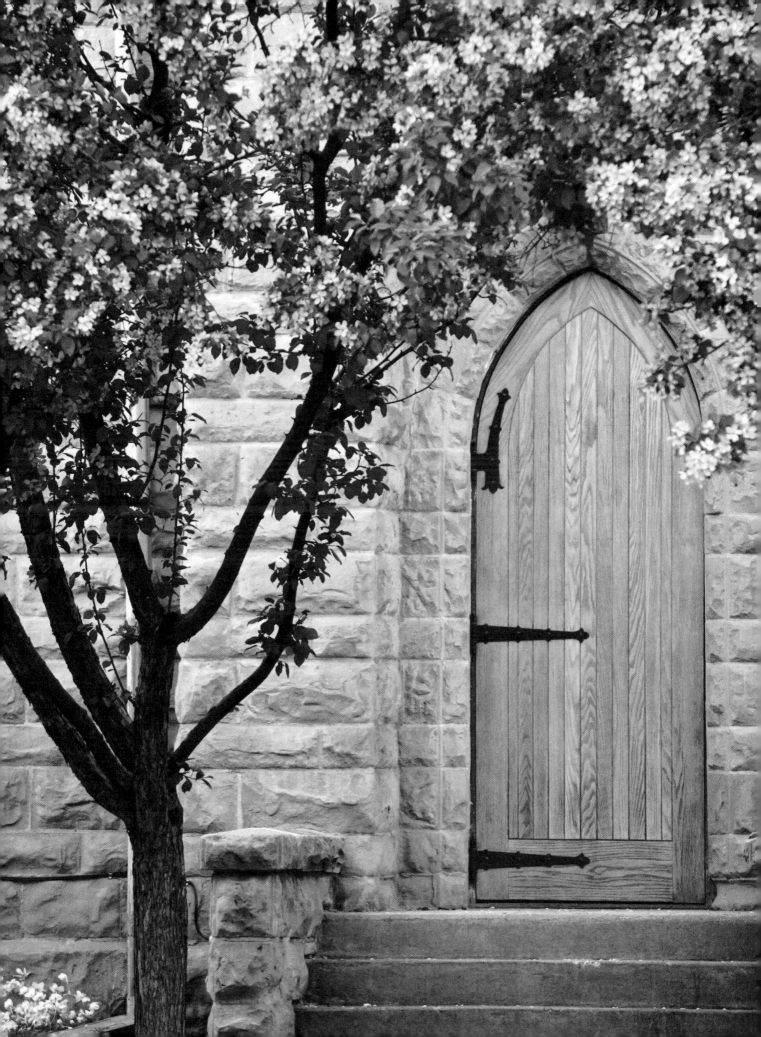

He was oppressed, and
he was afflicted, yet he opened not
his mouth; like a lamb that is led to the slaughter,
and like a sheep that before its shearers is silent,
so he opened not his mouth.

—Isaiah 53:7 (esv)

"Behold, the Lamb of God, who takes away the sin of the world!"
—John 1:29

The Lamb

William Blake

Little Lamb, who made thee?
Dost thou know who made thee?
Gave thee life and bid thee feed.
By the stream and o'er the mead;
gave thee clothing of delight,
softest clothing wooly bright;
gave thee such a tender voice,
making all the vales rejoice.

 Little Lamb, who made thee?
 Dost thou know who made thee?

Little Lamb, I'll tell thee,
Little Lamb, I'll tell thee:
He is called by thy name,
for he calls himself a Lamb.
He is meek, and he is mild;
he became a little child.
I a child, and thou a lamb,
we are called by his name.

 Little Lamb, God bless thee!
 Little Lamb, God bless thee!

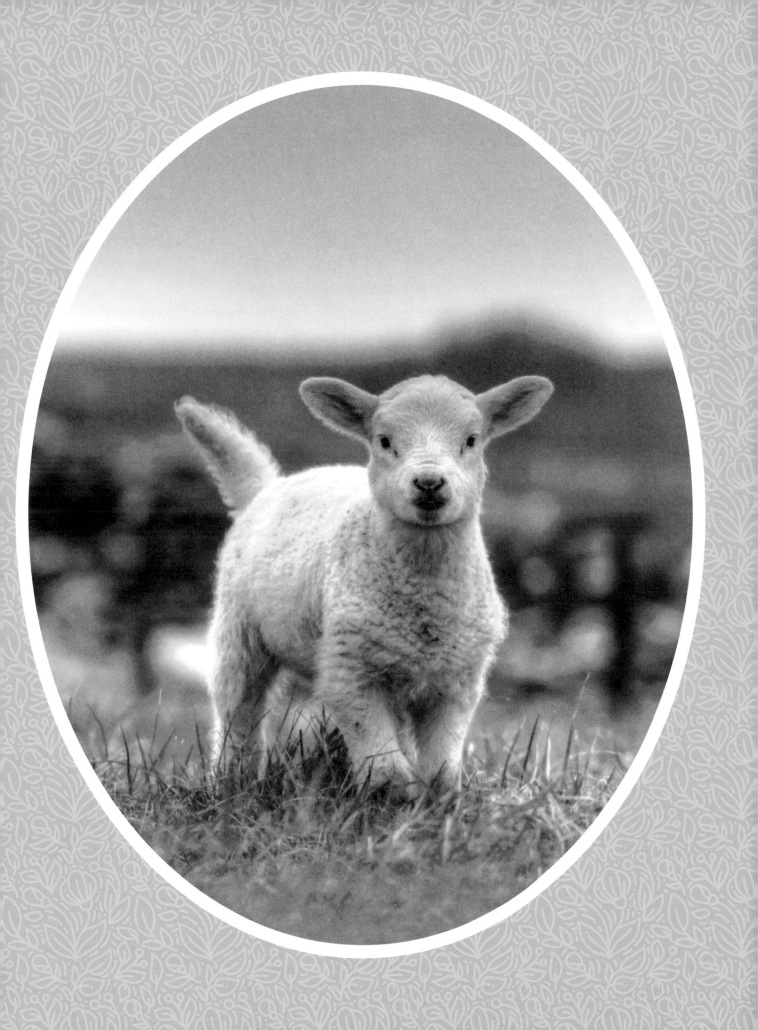

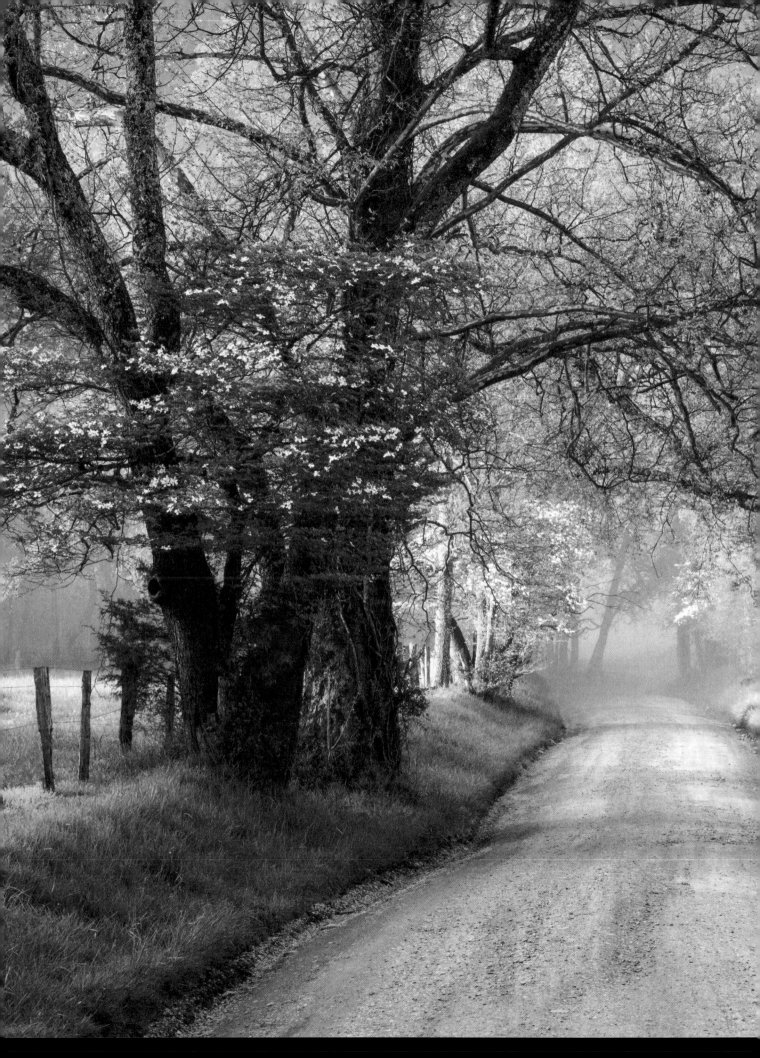

A Ballad of Trees and the Master
Sidney Lanier

Into the woods my Master went,
clean forspent, forspent;
into the woods my Master came,
forspent with love and shame.

But the olives they were not
 blind to Him,
the little gray leaves were
 kind to Him,
the thorn-tree had a mind to Him,
when into the woods He came.

Out of the woods my Master went,
and He was well content;
out of the woods my Master came,
content with death and shame.

When death and shame would
 woo Him last,
from under the trees they
 drew Him last,
'twas on a tree they slew Him last,
when out of the woods He came.

Cades Cove Great Smoky Mountains National Park. Image © Dave Allen/Adobe Stock

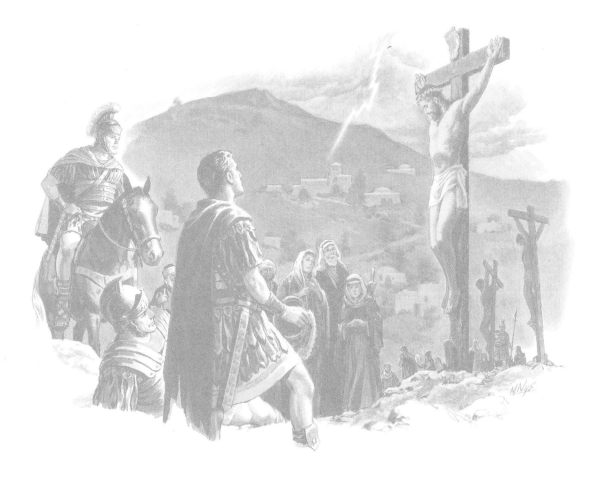

Were You There When They Crucified My Lord?

Traditional Spiritual

Were you there when they crucified my Lord?
Were you there when they crucified my Lord?
Oh, sometimes it causes me to
 tremble, tremble, tremble.
Were you there when they crucified my Lord?

Were you there when they nailed him to the tree?
Were you there when they nailed him to the tree?
Oh, sometimes it causes me to
 tremble, tremble, tremble.
Were you there when they nailed him to the tree?

Were you there when they pierced him in the side?
Were you there when they pierced him in the side?
Oh, sometimes it causes me to
 tremble, tremble, tremble.
Were you there when they pierced him in the side?

Were you there when they laid him in the tomb?
Were you there when they laid him in the tomb?
Oh, sometimes it causes me to
 tremble, tremble, tremble.
Were you there when they laid him in the tomb?

Were you there when God raised him
 from the tomb?
Were you there when God raised him
 from the tomb?
Oh, sometimes it causes me to
 tremble, tremble, tremble.
Were you there when God raised him
 from the tomb?

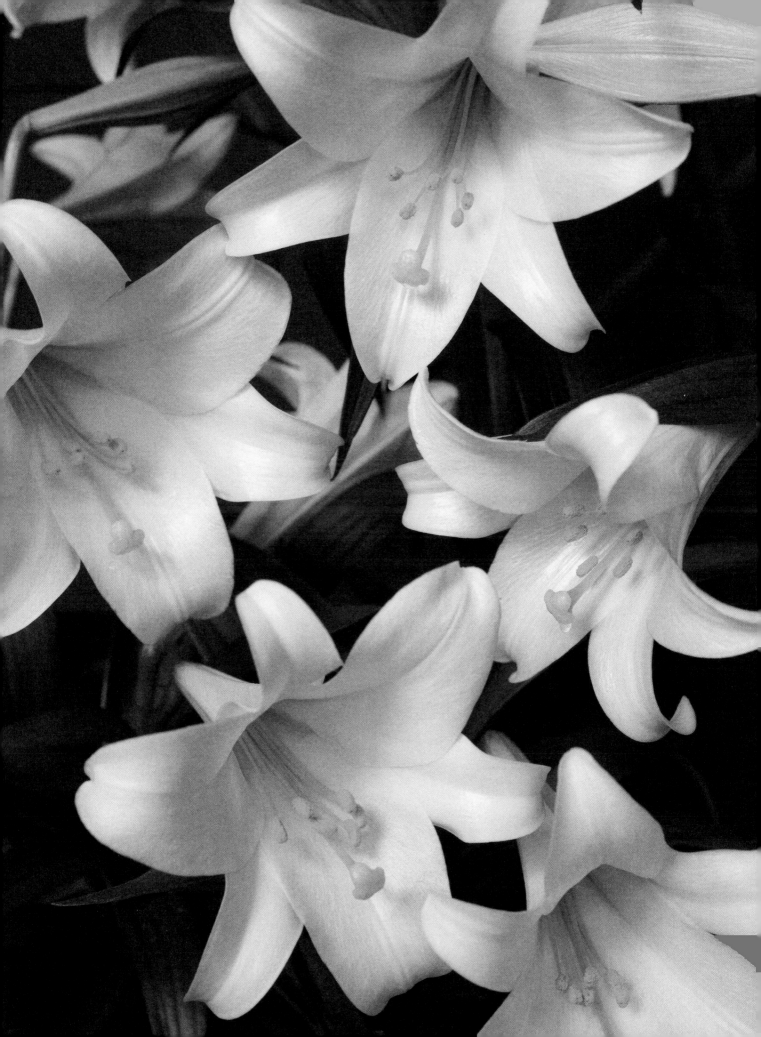

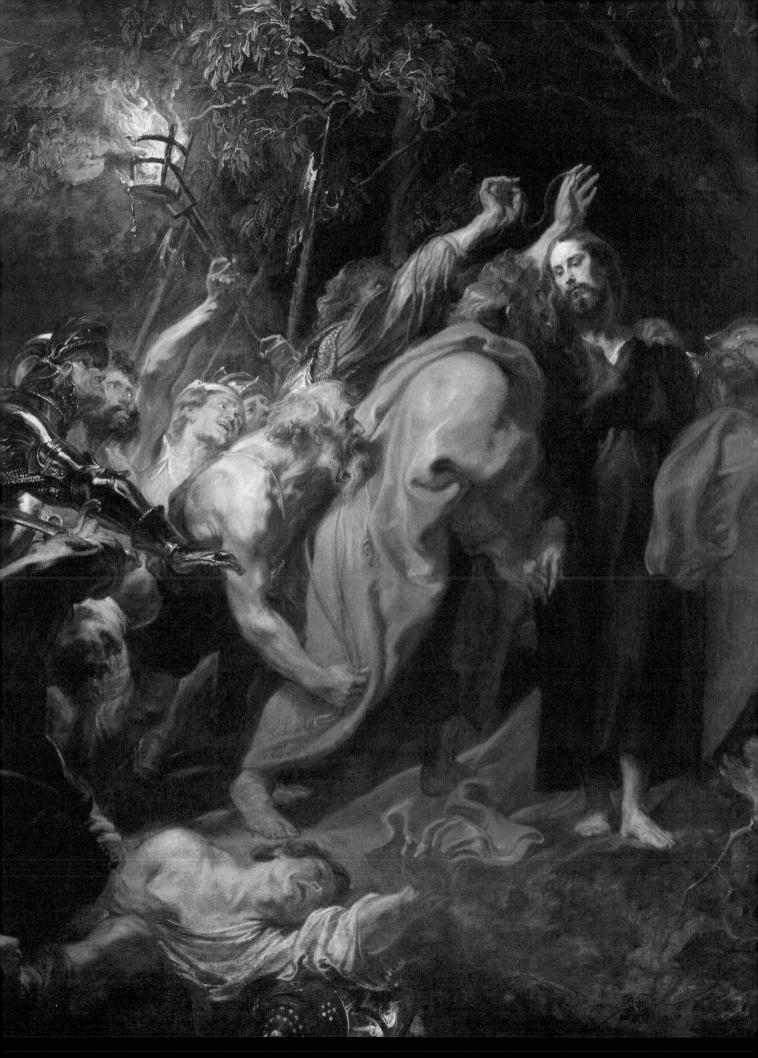

Betrayal and Arrest

Mark 14:27–50 (ESV)

And Jesus said to them, "You will all fall away, for it is written, 'I will strike the shepherd, and the sheep will be scattered.' But after I am raised up, I will go before you to Galilee."

Peter said to him, "Even though they all fall away, I will not." And Jesus said to him, "Truly, I tell you, this very night, before the rooster crows twice, you will deny me three times." But he said emphatically, "If I must die with you, I will not deny you." And they all said the same.

And they went to a place called Gethsemane. And he said to his disciples, "Sit here while I pray." And he took with him Peter and James and John, and began to be greatly distressed and troubled. And he said to them, "My soul is very sorrowful, even to death. Remain here and watch." And going a little farther, he fell on the ground and prayed that, if it were possible, the hour might pass from him. And he said, "Abba, Father, all things are possible for you. Remove this cup from me. Yet not what I will, but what you will."

And he came and found them sleeping, and he said to Peter, "Simon, are you asleep? Could you not watch one hour? Watch and pray that you may not enter into temptation. The spirit indeed is willing, but the flesh is weak." And again he went away and prayed, saying the same words. And again he came and found them sleeping, for their eyes were very heavy, and they did not know what to answer him. And he came the third time and said to them, "Are you still sleeping and taking your rest? It is enough; the hour has come. The Son of Man is betrayed into the hands of sinners. Rise, let us be going; see, my betrayer is at hand."

And immediately, while he was still speaking, Judas came, one of the twelve, and with him a crowd with swords and clubs, from the chief priests and the scribes and the elders. Now the betrayer had given them a sign, saying, "The one I will kiss is the man. Seize him and lead him away under guard." And when he came, he went up to him at once and said, "Rabbi!" And he kissed him. And they laid hands on him and seized him. But one of those who stood by drew his sword and struck the servant[b] of the high priest and cut off his ear.

And Jesus said to them, "Have you come out as against a robber, with swords and clubs to capture me? Day after day I was with you in the temple teaching, and you did not seize me. But let the Scriptures be fulfilled." And they all left him and fled.

THE CAPTURE OF CHRIST *by Peinture d' Anthony van Dyck. Image © Bridgeman Images.*

Trial and Crucifixion

Matthew 27:27–54 (ESV)

Then the soldiers of the governor took Jesus into the governor's headquarters, and they gathered the whole battalion before him. And they stripped him and put a scarlet robe on him, and twisting together a crown of thorns, they put it on his head and put a reed in his right hand. And kneeling before him, they mocked him, saying, "Hail, King of the Jews!" And they spit on him and took the reed and struck him on the head. And when they had mocked him, they stripped him of the robe and put his own clothes on him and led him away to crucify him.

As they went out, they found a man of Cyrene, Simon by name. They compelled this man to carry his cross. And when they came to a place called Golgotha (which means Place of a Skull), they offered him wine to drink, mixed with gall, but when he tasted it, he would not drink it. And when they had crucified him, they divided his garments among them by casting lots.

Now from the sixth hour there was darkness over all the land until the ninth hour. And about the ninth hour Jesus cried out with a loud voice, saying, *"Eli, Eli, lema sabachthani?"* that is, "My God, my God, why have you forsaken me?"

And some of the bystanders, hearing it, said, "This man is calling Elijah." And one of them at once ran and took a sponge, filled it with sour wine, and put it on a reed and gave it to him to drink. But the others said, "Wait, let us see whether Elijah will come to save him."

And Jesus cried out again with a loud voice and yielded up his spirit. And behold, the curtain of the temple was torn in two, from top to bottom. And the earth shook, and the rocks were split. The tombs also were opened. And many bodies of the saints who had fallen asleep were raised, and coming out of the tombs after his resurrection they went into the holy city and appeared to many. When the centurion and those who were with him, keeping watch over Jesus, saw the earthquake and what took place, they were filled with awe and said, "Truly this was the Son of God!"

CHRIST CARRYING THE CROSS *by Giovanni Battista Moroni. Image © M. Carrieri, NPL–DeA Picture Library/Bridgeman Images*

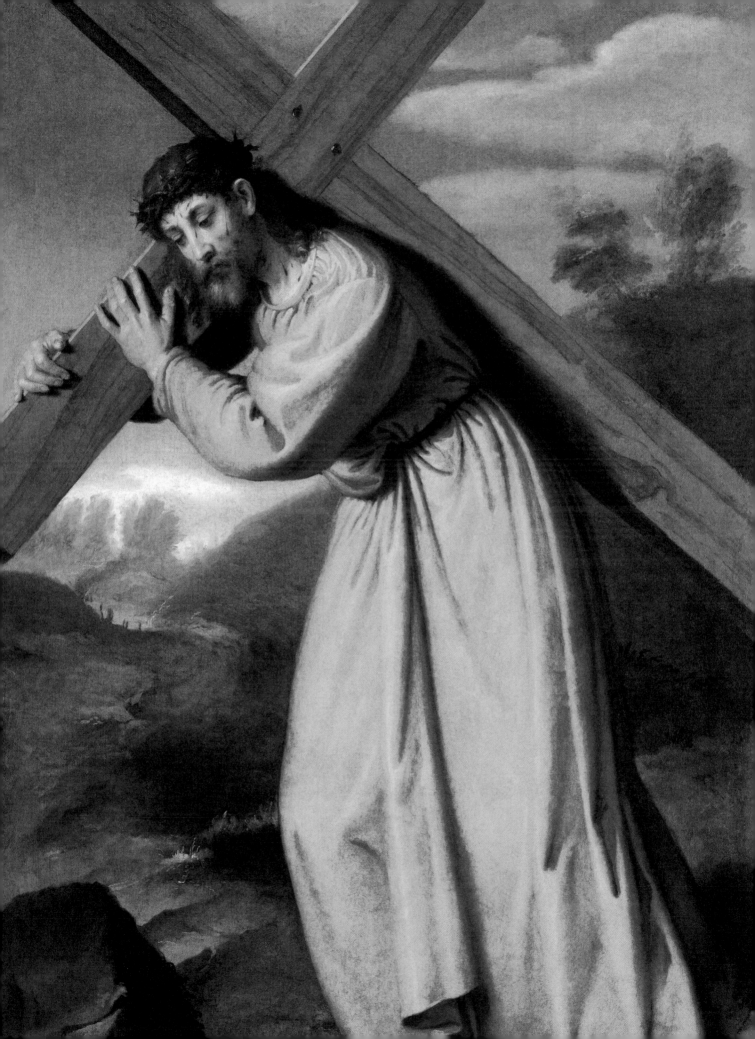

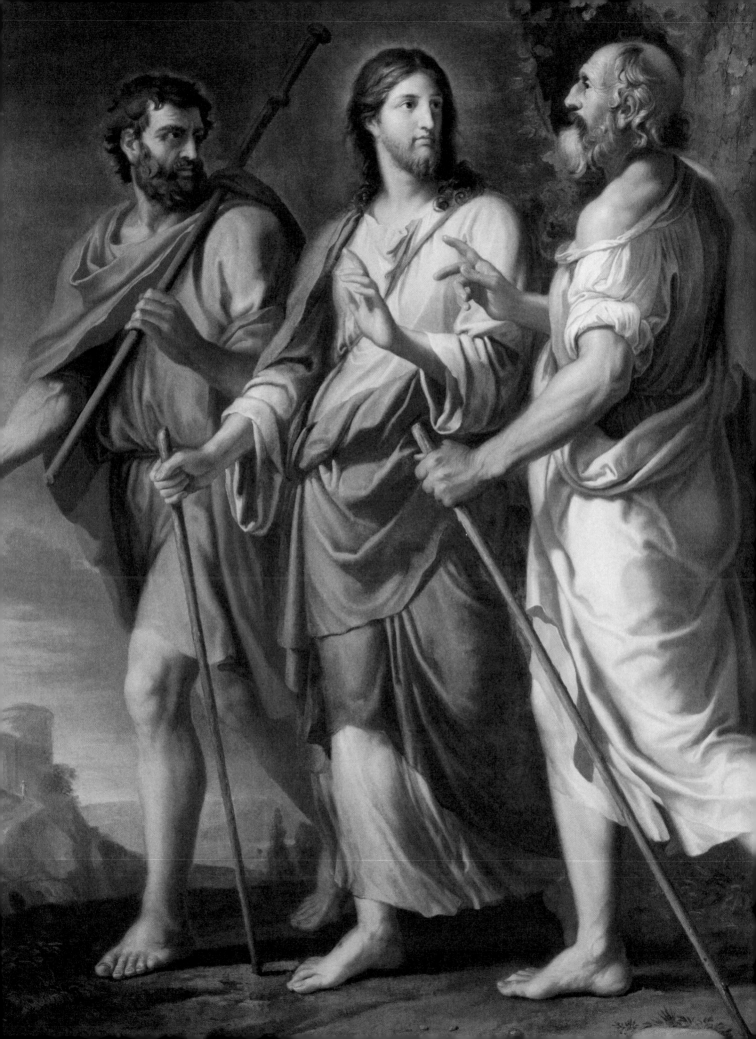

Resurrection and Appearance
Luke 24:1–9, 13–27 (ESV)

But on the first day of the week, at early dawn, they went to the tomb, taking the spices they had prepared. And they found the stone rolled away from the tomb, but when they went in they did not find the body of the Lord Jesus. While they were perplexed about this, behold, two men stood by them in dazzling apparel. And as they were frightened and bowed their faces to the ground, the men said to them, "Why do you seek the living among the dead? He is not here, but has risen. . . ."

That very day two of them were going to a village named Emmaus, about seven miles from Jerusalem, and they were talking with each other about all these things that had happened. While they were talking and discussing together, Jesus himself drew near and went with them. But their eyes were kept from recognizing him.

And he said to them, "What is this conversation that you are holding with each other as you walk?"

And they stood still, looking sad. Then one of them, named Cleopas, answered him, "Are you the only visitor to Jerusalem who does not know the things that have happened there in these days?"

And he said to them, "What things?" And they said to him, "Concerning Jesus of Nazareth, a man who was a prophet mighty in deed and word before God and all the people, and how our chief priests and rulers delivered him up to be condemned to death, and crucified him. But we had hoped that he was the one to redeem Israel. Yes, and besides all this, it is now the third day since these things happened. Moreover, some women of our company amazed us. They were at the tomb early in the morning, and when they did not find his body, they came back saying that they had even seen a vision of angels, who said that he was alive. Some of those who were with us went to the tomb and found it just as the women had said, but him they did not see."

And he said to them, "O foolish ones, and slow of heart to believe all that the prophets have spoken! Was it not necessary that the Christ should suffer these things and enter into his glory?" And beginning with Moses and all the Prophets, he interpreted to them in all the Scriptures the things concerning himself.

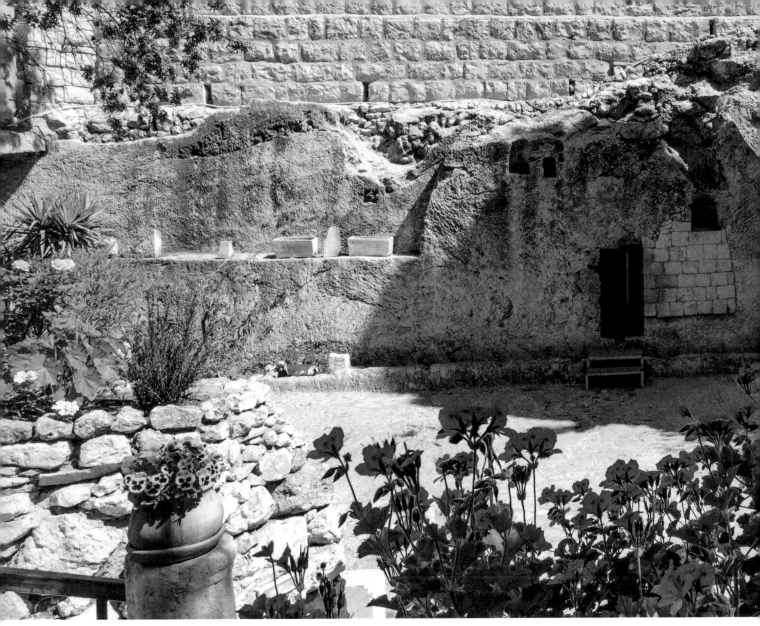

Purple flowers at the Garden Tomb, Jerusalem. Image © John Theodor/Shutterstock

Christ the Lord Is Risen Today

Charles Wesley

Christ the Lord is risen today, Alleluia!
Earth and heaven in chorus say, Alleluia!
Raise your joys and triumphs high, Alleluia!
Sing, ye heavens, and earth reply, Alleluia!

Love's redeeming work is done, Alleluia!
Fought the fight, the battle won, Alleluia!
Death in vain forbids him rise, Alleluia!
Christ has opened paradise, Alleluia!

Lives again our glorious King, Alleluia!
Where, O death, is now thy sting? Alleluia!
Once he died our souls to save, Alleluia!
Where's thy victory, boasting grave? Alleluia!

Soar we now where Christ has led, Alleluia!
Following our exalted Head, Alleluia!
Made like him, like him we rise, Alleluia!
Ours the cross, the grave, the skies, Alleluia!

Hail the Lord of earth and heaven, Alleluia!
Praise to thee by both be given, Alleluia!
Thee we greet triumphant now, Alleluia!
Hail the Resurrection, thou, Alleluia!

King of glory, soul of bliss, Alleluia!
Everlasting life is this, Alleluia!
Thee to know, thy power to prove, Alleluia!
Thus to sing, and thus to love, Alleluia!

**"Worthy is the Lamb who was slain, to receive power and wealth and
wisdom and might and honor and glory and blessing!" And I heard every
creature in heaven and on earth and under the earth and in the sea,
and all that is in them, saying, 'To him who sits on the throne and to the Lamb be
blessing and honor and glory and might forever and ever!'"**

—Revelation 5:12–13 (esv)

Let me hear in the morning of your steadfast love, for in you I trust.
—Psalm 143:8 (esv)

Dawn

Laurence Dunbar

An angel, robed in
 spotless white,
bent down and kissed
 the sleeping Night.
Night woke to blush;
 the sprite was gone.
Men saw the blush
 and called it Dawn.

Day!

Robert Browning

Faster and more fast,
o'er night's brim, day boils at last:
boils, pure gold, o'er the cloud-cup's brim
where spurting and suppressed it lay,
for not a froth-flake touched the rim
of yonder gap in the solid gray
of the eastern cloud, an hour away;
but forth one wavelet, then another, curled,
till the whole sunrise, not to be suppressed,
rose, reddened, and its seething breast
flickered in bounds, grew gold, then overflowed
 the world.

Boca Raton, Florida. Image © Tom Grill, Tetra Images/SuperStock

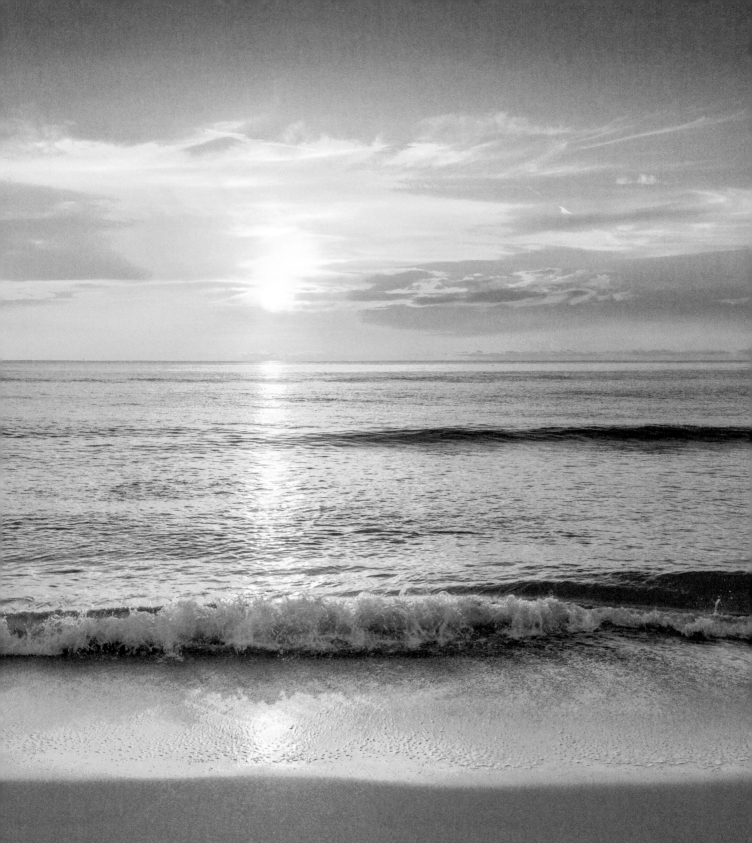

Out of mystery and gloom,
 out of sorrow and the tomb,
 Comes a carol brave and gay,
 comes the breaking of the day.
—AUTHOR UNKNOWN

The Big Fisherman

Lloyd C. Douglas

And now it was Wednesday morning. Thad had gone ashore on an errand. Simon's knees were lame from his unaccustomed exercise; and after an hour of it, he came wearily to his feet and walked the length of the deck, wondering what had detained the boy. Three dories were on the water and moving rapidly, their oars flashing in the sun. With narrowed eyes, shaded by his cupped hands, Simon identified the occupants of the boats. Thad was bringing Andrew. James and John were in the second dory which had overtaken and was now passing Thad. Lagging behind came Philip with Thomas and old Bartholomew.

Simon's heart was in his throat. How could he face these men? They were drawing closer now, near enough for him to see their animation. They seemed happy! Whatever could have happened? He tossed a rope to the first dory and Johnny scrambled up, flung a leg over the rail and threw his arms around the bewildered skipper.

"You haven't heard!" he shouted, exultantly. "You don't know! Listen! Jesus lives! . . . I tell you—he is alive!"

James had grasped Simon's arm.

"We have seen him, Peter! He came to us—Sunday night—at Benyosef's house!"

They had all swarmed over the rail now, all but Bartholomew who was being tugged on board by Thad. Simon stood there dazed, his lips quivering, the tears running down his cheeks.

"He told us to make haste, and go home," said Philip. "He was anxious for you to know."

"That's what he said," put in Johnny. "He said, 'Go and tell Peter!'"

"Are you sure he said 'Peter'?" asked the Big Fisherman, huskily.

"Aye! That he did!" declared Bartholomew. "'Go, quickly, and tell Peter!'"

"Where is he now?" entreated Peter. "I must go to him!"

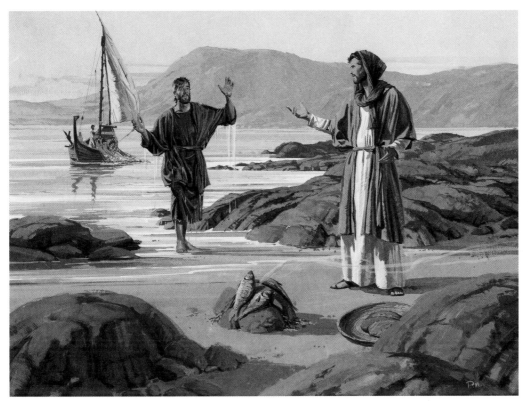

IT IS THE LORD *by Paul Mann. Image © Lifeway Collection/GoodSalt Inc.*

"We're to wait here," said Andrew. "He is coming to us."

At the first gray-blue light before dawn, the Big Fisherman rose and walked forward. It was still too early to identify the familiar landmarks. On such a morning, he had stood here gazing toward the shore in the pre-dawn haze and had heard a voice calling "Simon!" With what heart-racing haste had he scrambled into the little boat and flailed the lake with excited oars! And then he had received his commission as the fisherman who would now "fish for men."

The sky was brightening a little and the fog was dissolving. Dimly the outlines of the wharves and huts became visible. The Big Fisherman's narrowed eyes slowly swept the shoreline. A tall, slender column of blue smoke was rising from a small, bright fire at the water's edge. Beside the fire, warming his hands, stood the Master. He raised his arm, waved a hand, and called:

"Peter!"

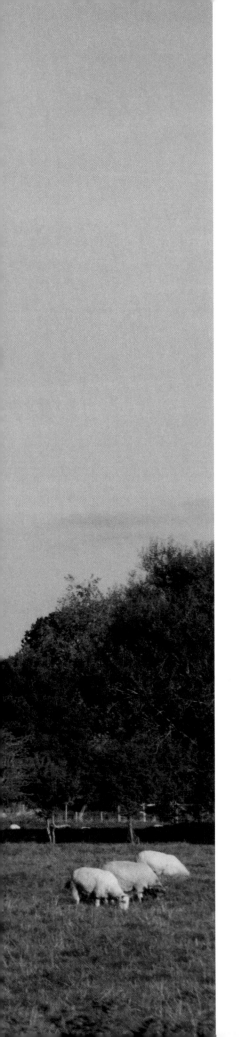

Feed My Sheep

John 21:9–17 (ESV)

When they got out on land, they saw a charcoal fire in place, with fish laid out on it, and bread.

Jesus said to them, "Bring some of the fish that you have just caught."

So Simon Peter went aboard and hauled the net ashore, full of large fish, 153 of them. And although there were so many, the net was not torn.

Jesus said to them, "Come and have breakfast." Now none of the disciples dared ask him, "Who are you?" They knew it was the Lord. Jesus came and took the bread and gave it to them, and so with the fish. This was now the third time that Jesus was revealed to the disciples after he was raised from the dead.

When they had finished breakfast, Jesus said to Simon Peter, "Simon, son of John, do you love me more than these?"

He said to him, "Yes, Lord; you know that I love you."

He said to him, "Feed my lambs."

He said to him a second time, "Simon, son of John, do you love me?"

He said to him, "Yes, Lord; you know that I love you."

He said to him, "Tend my sheep."

He said to him the third time, "Simon, son of John, do you love me?"

Peter was grieved because he said to him the third time, "Do you love me?" and he said to him, "Lord, you know everything; you know that I love you."

Jesus said to him, "Feed my sheep.

Salisbury Cathedral. Image © John Philip Harper/SuperStock

Sleepers, Awake!

Emyl Jenkins

When I was growing up in Danville, Virginia, attending the Easter Sunday sunrise service in the quaint Moravian restoration of Old Salem in Winston-Salem, North Carolina, was a tradition. Cars and buses full of worshippers started out in the dark of night to arrive in the village just in time to see the lights in the old brick and timber houses come on as the sleeping town was awakened to a rousing chorus of "Sleepers, Awake!" played by a magnificent brass band.

While the moon was still high, thousands of visitors of every sect, creed, and race paraded from the steps of the Home Church, where they had gathered, to the nearby resting place of the Moravian dead, God's Acre, as Moravian cemeteries are called. When all were assembled, prayers were given and songs were sung, and antiphonal brass choruses were played while everyone awaited the dawning of Easter morn.

Silently and wondrously the bright moon that had lighted the worshippers' way slowly began to lose its glow as the sky turned from pitch black to an azure blue. Silently and wondrously a soft yellow-pink glow spread across the earth. Then in a sudden burst from behind the majestic, newly budded and leafed trees in the east, the sun appeared.

In that emotionally charged moment the benediction was pronounced: "Go forth!" In the distance, the last deep, compelling tones of the brass horns hung in the morning mist, bringing, for another year, the sacred service to an end. Yet few of the worshippers left. Peacefully, reverently, the guests lingered, wanting the moment, the morning, and the peace to last.

Image © Ryzhkov Oleksandr/Adobe Stock

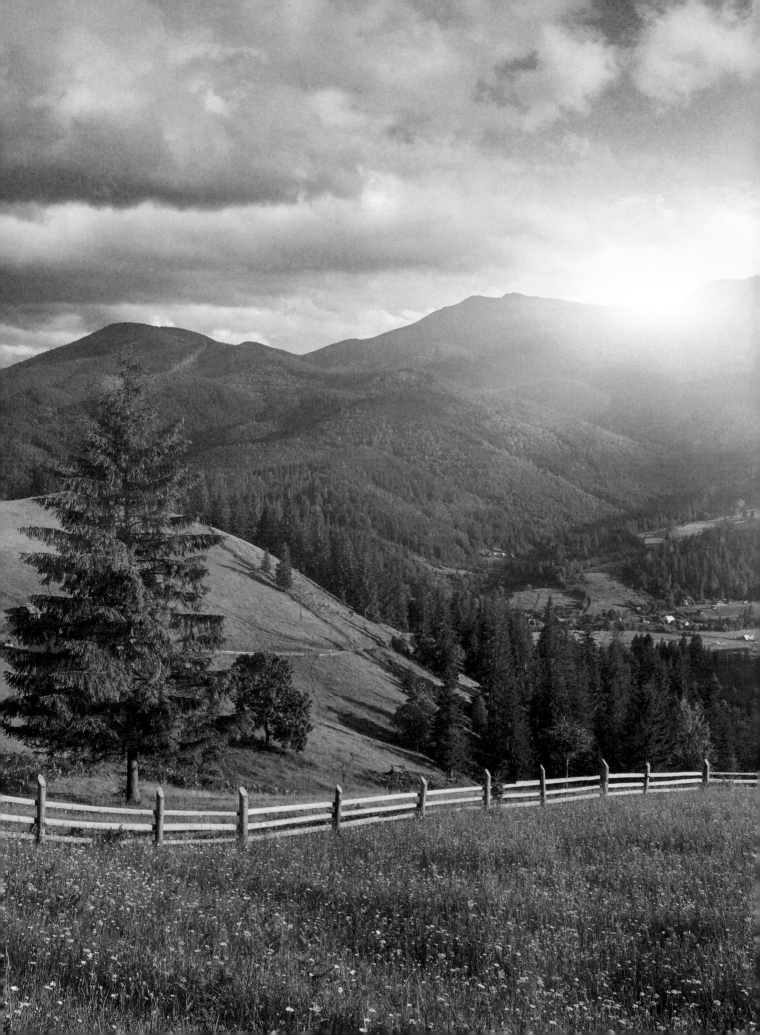

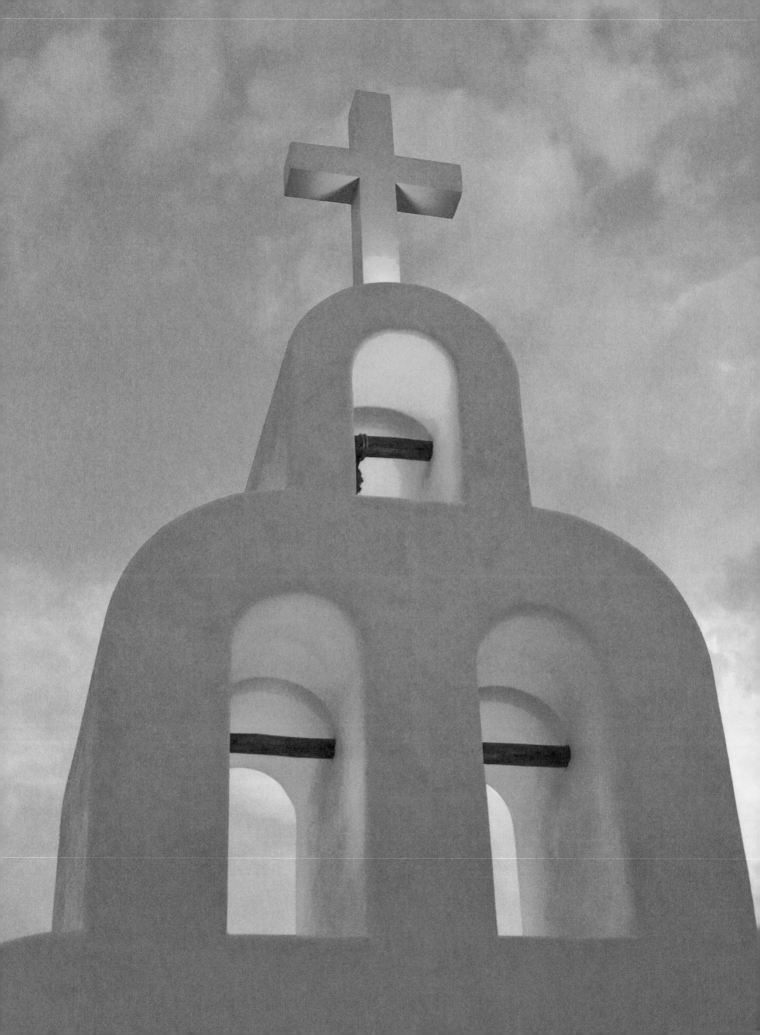

Church Bells Ring

J. H. Kurzenknabe

Let the merry church bells ring,
hence with tears and sighing;
frost and cold have fled from spring;
life hath conquered dying;
flowers are smiling, fields are gay,
sunny is the weather;
with our risen Lord today,
all things rise together.

Let the birds sing out again
from their leafy chapel,
praising Him with whom in vain
sin hath sought to grapple.

Sounds of joy come loud and clear
as the breezes flutter;
"He arose and is not here"
is the strain they utter.

Let the past of grief be past;
this our comfort giveth;
He was slain on Friday last,
but today He liveth.
Mourning hearts must now be gay,
out of sorrow's prison,
since the very grave can say,
"He hath arisen!"

Easter Bells

Carrie Law Morgan Figgs

Hark! What sound is this I hear?
Such music it foretells,
the sound is soft, but sweet and clear,
it must be Easter bells.

Sweet bells, your music fills my soul
and wraps me in a spell,
your wondrous peals like ocean's roll,
oh magical Easter bells.

Ring on, sweet bells,
ring loud and clear,
help men to understand
that Jesus Christ our Saviour dear
broke death's cold, iron band.

Tell them "He rose just as He said,"
spread it o'er vale and dell,
the joyful tidings onward spread,
ye heaven-sent Easter bells.

Let every heart rejoice today
and crush in sin's hard shell
and raise to heaven a joyous lay,
as do these chiming Easter bells.

Ring on, sweet bells, ring more
 and more
and hold me in your spell,
until I reach that shining shore
where rings everlasting Easter bells.

Family Recipes

Tres Leches Cake with Berries

CAKE

- 1 cup all-purpose flour
- ½ teaspoon baking powder
- ½ teaspoon baking soda
- ¼ teaspoon salt
- ¾ cup granulated sugar
- ¼ cup butter, softened
- 2 teaspoons vanilla extract
- 2 large eggs
- ½ cup milk

TOPPINGS

- 2 cups heavy cream
- ¼ cup confectioners' sugar
- 1 teaspoon vanilla extract, divided
- 1 cup half and half
- ⅓ cup sweetened condensed milk
- 1 cup fresh raspberries
- 1 cup fresh blueberries

Preheat oven to 350°F. Grease and flour 8-inch round cake pan; set aside. In a medium bowl, combine flour, baking powder, baking soda, and salt. Mix well; set aside. In a large bowl, combine granulated sugar, butter, and 2 teaspoons vanilla extract; beat on medium speed until combined. Add eggs; beat until light and fluffy. Add flour mixture to butter mixture, beating on low until mixed. Stir in ½ cup milk. Pour batter into prepared pan. Bake 24 to 29 minutes or until toothpick inserted in center comes out clean. Cool on rack 5 minutes. Turn out of pan onto cooling rack; cool completely.

To make frosting, in a medium bowl, combine heavy cream, confectioners' sugar, and ½ teaspoon vanilla extract; beat at high speed until stiff peaks form. Refrigerate. To make milk mixture, in a small bowl, combine half and half, sweetened condensed milk, and remaining vanilla extract. Slice cooled cake in half horizontally. Place one layer, cut-side up, onto serving plate. Slowly pour half of milk mixture over top, allowing it to soak in. Spread ½-inch layer of frosting onto soaked cake. Top with second cake layer, cut-side up. Pour remaining milk mixture over top. Spread remaining frosting over top. Serve with fresh berries. *Note*: Cake must be stored in refrigerator. Makes 10 to 12 servings.

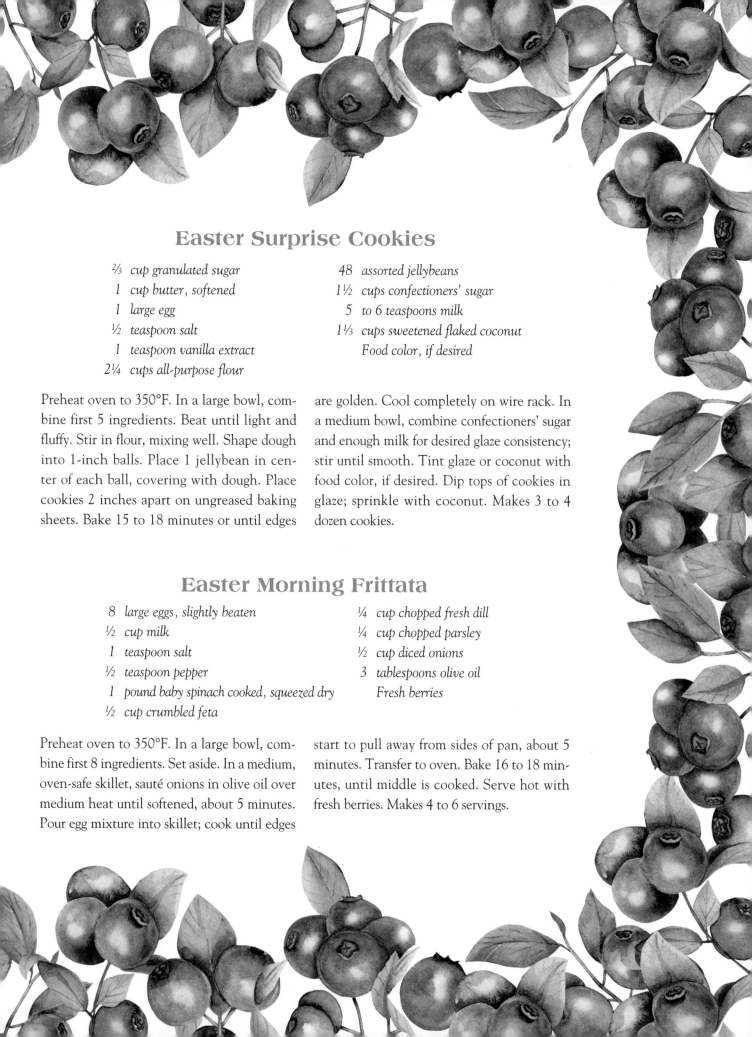

Easter Surprise Cookies

⅔ cup granulated sugar
1 cup butter, softened
1 large egg
½ teaspoon salt
1 teaspoon vanilla extract
2¼ cups all-purpose flour

48 assorted jellybeans
1½ cups confectioners' sugar
5 to 6 teaspoons milk
1⅓ cups sweetened flaked coconut
Food color, if desired

Preheat oven to 350°F. In a large bowl, combine first 5 ingredients. Beat until light and fluffy. Stir in flour, mixing well. Shape dough into 1-inch balls. Place 1 jellybean in center of each ball, covering with dough. Place cookies 2 inches apart on ungreased baking sheets. Bake 15 to 18 minutes or until edges are golden. Cool completely on wire rack. In a medium bowl, combine confectioners' sugar and enough milk for desired glaze consistency; stir until smooth. Tint glaze or coconut with food color, if desired. Dip tops of cookies in glaze; sprinkle with coconut. Makes 3 to 4 dozen cookies.

Easter Morning Frittata

8 large eggs, slightly beaten
½ cup milk
1 teaspoon salt
½ teaspoon pepper
1 pound baby spinach cooked, squeezed dry
½ cup crumbled feta

¼ cup chopped fresh dill
¼ cup chopped parsley
½ cup diced onions
3 tablespoons olive oil
Fresh berries

Preheat oven to 350°F. In a large bowl, combine first 8 ingredients. Set aside. In a medium, oven-safe skillet, sauté onions in olive oil over medium heat until softened, about 5 minutes. Pour egg mixture into skillet; cook until edges start to pull away from sides of pan, about 5 minutes. Transfer to oven. Bake 16 to 18 minutes, until middle is cooked. Serve hot with fresh berries. Makes 4 to 6 servings.

An Easter Prayer
Rebecca Barlow Jordan

Lord, we celebrate life
because You have given us a
new beginning.
We choose to love
because You first loved us.
We desire to give
because You gave yourself
in obedience.

We ask Your blessing,
Your guidance,
and Your wisdom
that we might share
the good news
that can rebuild faith,
shatter fear,
and dispense hope
to all who will receive.

Prayer for This House
Louis Untermeyer

May nothing evil cross this door,
and may ill-fortune never pry
about these windows; may the roar
and rains go by.

Strengthened by faith, the rafters will
withstand the battering of the storm;
this hearth, though all the world grow chill,
will keep you warm.

Peace shall walk softly through these rooms,
touching your lips with holy wine,
till every casual corner blooms
into a shrine.

Laughter shall drown the raucous shout
and, though the sheltering walls are thin,
may they be strong to keep hate out
and hold love in.

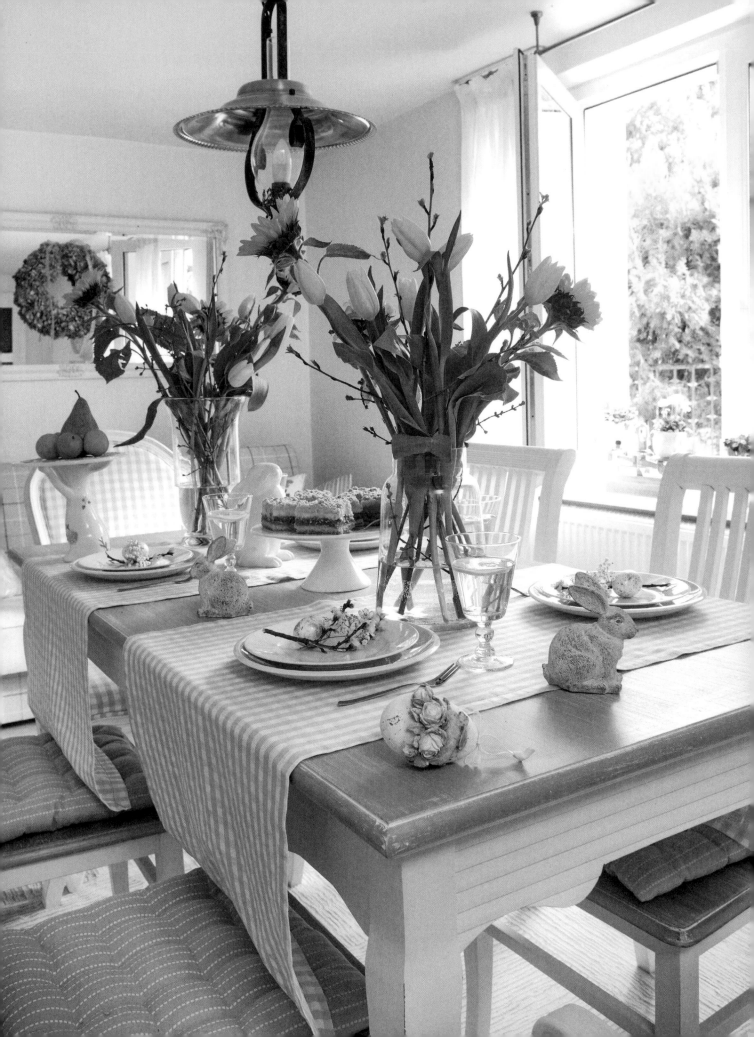

I Shall Remember

Isabella Wood Johnson

I shall remember other Easter Days:
the smell of hyacinths, a choir song,
the cool, soft drift of cherry blooms along
the heartfelt sweetness of the April ways,
a sunrise service, quietness that prays,
the organ's swell, a union in the throng
of worshippers. I shall remember long
the pristine whiteness of the lily sprays.

ISBN: 978-1-5460-0089-1

Published by Ideals
Hachette Book Group
1290 Avenue of the Americas
New York, NY 10104

Printed and bound in the U.S.A.

Publisher, Peggy Schaefer
Editor, Patricia A. Pingry
Senior Editor, Melinda Rathjen
Designer, Marisa Jackson
Associate Editor & Permissions, Kristi Breeden
Copy Editor, Amanda Varian

Cover: Image © Howard Rice/GAP Photos.
Additional art credits: Art for "Bits & Pieces" by Emily van Wyk.
Inside front cover: *Easter Bunnnies* by Daniel Rodgers. Image © Daniel Rodgers/Advocate Art.
Inside back cover: *Garden Path* by Daniel Rodgers. Image © Daniel Rodgers/Advocate Art.

Want more homey philosophy, poetry, inspiration, and art? Be sure to look for our annual issue of *Christmas Ideals* at your favorite store.

Join a community of *Ideals* readers on Facebook at: www.facebook.com/IdealsMagazine
Readers are invited to submit original poetry and prose for possible use in future publications. Please send no more than four typed submissions to: Hachette Book Group, Attn: Ideals Submissions, 6100 Tower Circle, Suite 210, Franklin, Tennessee 37067. Editors cannot guarantee your material will be used, but we will contact you if we do wish to publish.

ACKNOWLEDGMENTS

BORLAND, HAL. "Thus We Come to Easter" excerpted from *This Hill, This Valley*, Copyright © 1957 by Hal Borland. Copyright © renewed 1985 by Barbara Dodge Borland. All rights reserved. Used by permission of Frances Collin, Literary Agent. DOUGLAS, LLOYD C. "The Big Fisherman" excerpted from *The Big Fisherman*, Copyright © 1948 by Lloyd C. Douglas, published by Houghton Mifflin Company. Used by permission of heirs. JENKINS, EMYL. "Sleepers Awake!" excerpted from *The Book of American Traditions*, Copyright © 1996 by Emyl Jenkins. Published by Crown Publishers. Used by permission of heirs. TABER, GLADYS. "Springtime in the Country" from COUNTRY CHRONICLE by Gladys Taber, copyright © 1974 by Glady's Taber. Used by permission of Brandt & Hochman Literary Agents, Inc. OUR THANKS to the following authors or their heirs for permission granted or for material submitted for publication: Anne Kennedy Brady, Clara Brummert,

Marianne Coyne, Linda C. Grazulis, Rebecca Barlow Jordan, Pamela Kennedy, Pamela Love, and Eileen Spinelli.

Scripture quotations, unless otherwise indicated, are taken from the King James Version (KJV). Scripture quotations marked ESV are taken from the ESV® Bible (The Holy Bible, English Standard Version®), copyright © 2001 by Crossway, a publishing ministry of Good News Publishers. Used by permission. All rights reserved.

Every effort has been made to establish ownership and use of each selection in this book. If contacted, the publisher will be pleased to rectify any inadvertent errors or omissions in subsequent editions.

Printing 1, 2021